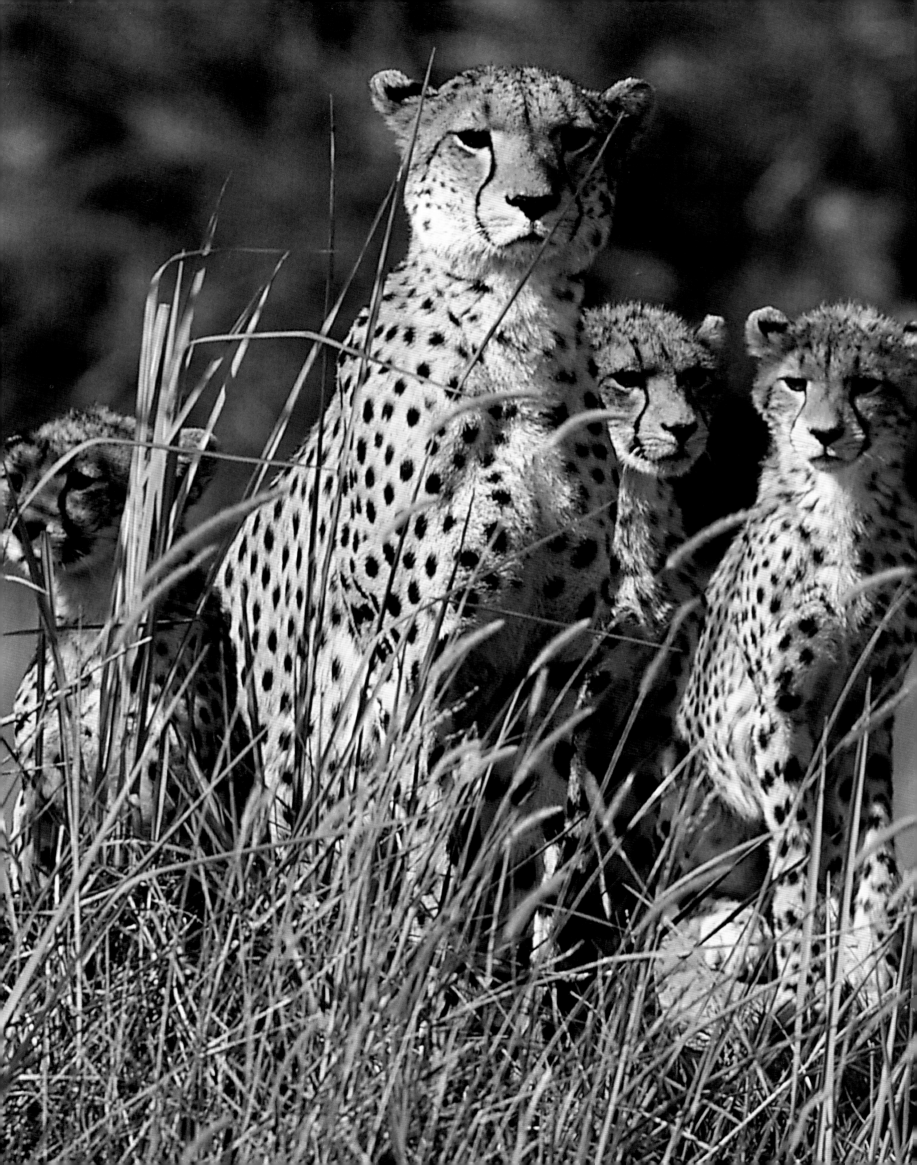

CHEETAH

LUKE HUNTER

DAVE HAMMAN

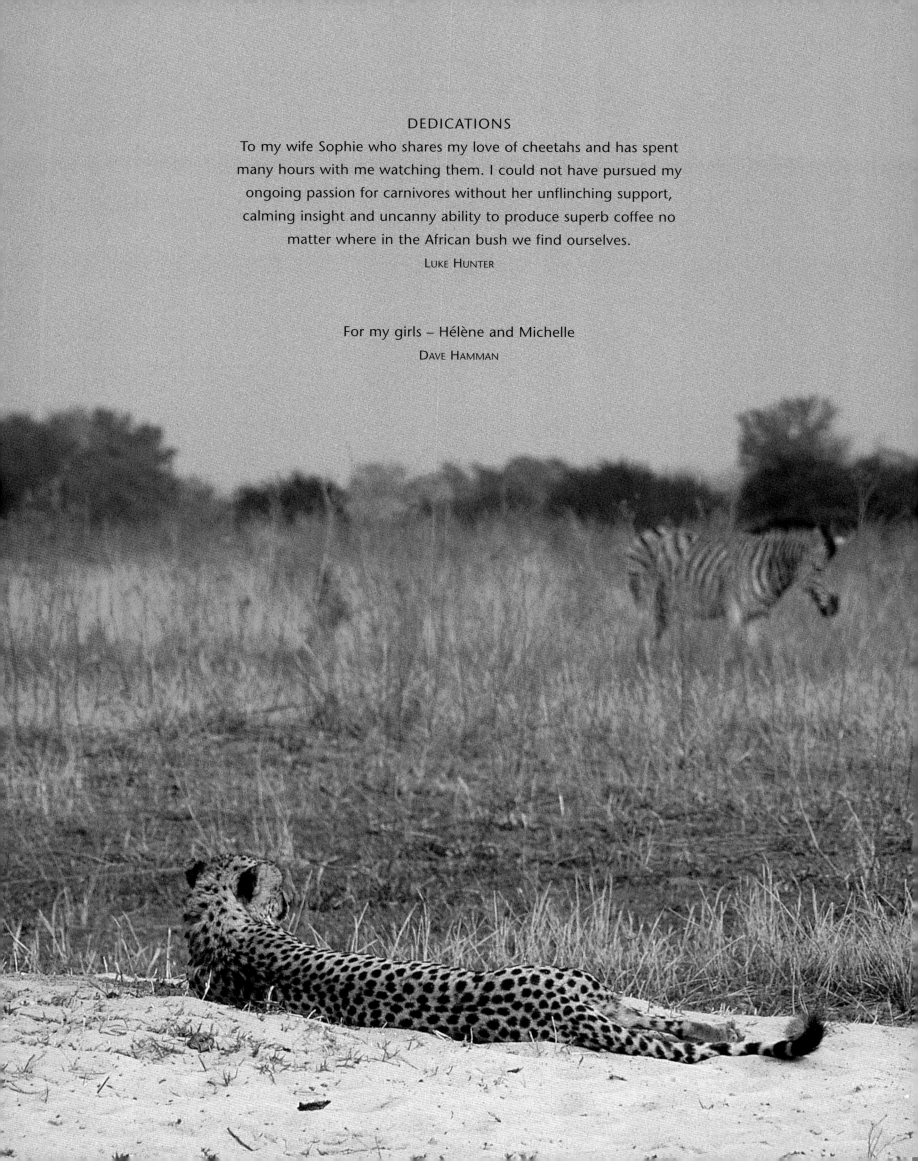

DEDICATIONS

To my wife Sophie who shares my love of cheetahs and has spent many hours with me watching them. I could not have pursued my ongoing passion for carnivores without her unflinching support, calming insight and uncanny ability to produce superb coffee no matter where in the African bush we find ourselves.

LUKE HUNTER

For my girls – Hélène and Michelle

DAVE HAMMAN

Struik Publishers
(a division of New Holland Publishing
South Africa) (Pty) Ltd)
Cornelis Struik House
80 McKenzie Street
Cape Town 8001

New Holland Publishing is a member of the
Johnnic Publishing Group.

Visit us at
www.struik.co.za

Log on to our photographic website
www.imagesofafrica.co.za
for an African experience.

First published in 2003

1 3 5 7 9 10 8 6 4 2

Publishing manager: Pippa Parker
Managing editor: Helen de Villiers
Editor: Roxanne Reid
Designer: Janice Evans
Cover concept: Dominic Robson & Janice Evans
Map & chart: David du Plessis

Reproduction by Hirt & Carter Cape (Pty) Ltd
Printed and bound by Sirivatana Interprint Public Co Ltd

ISBN 1 86872 719 X

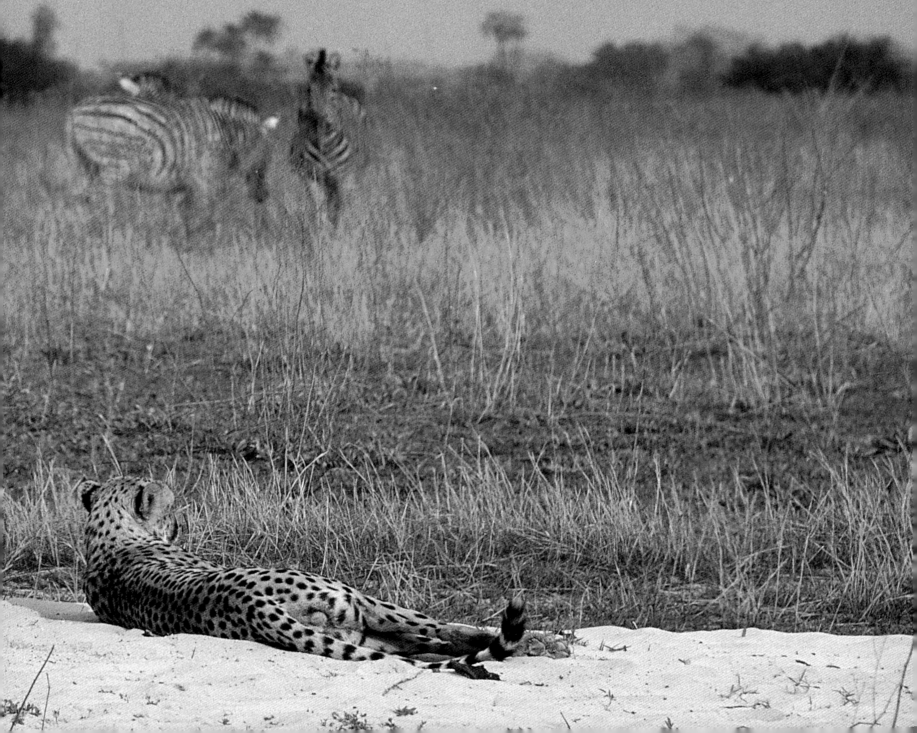

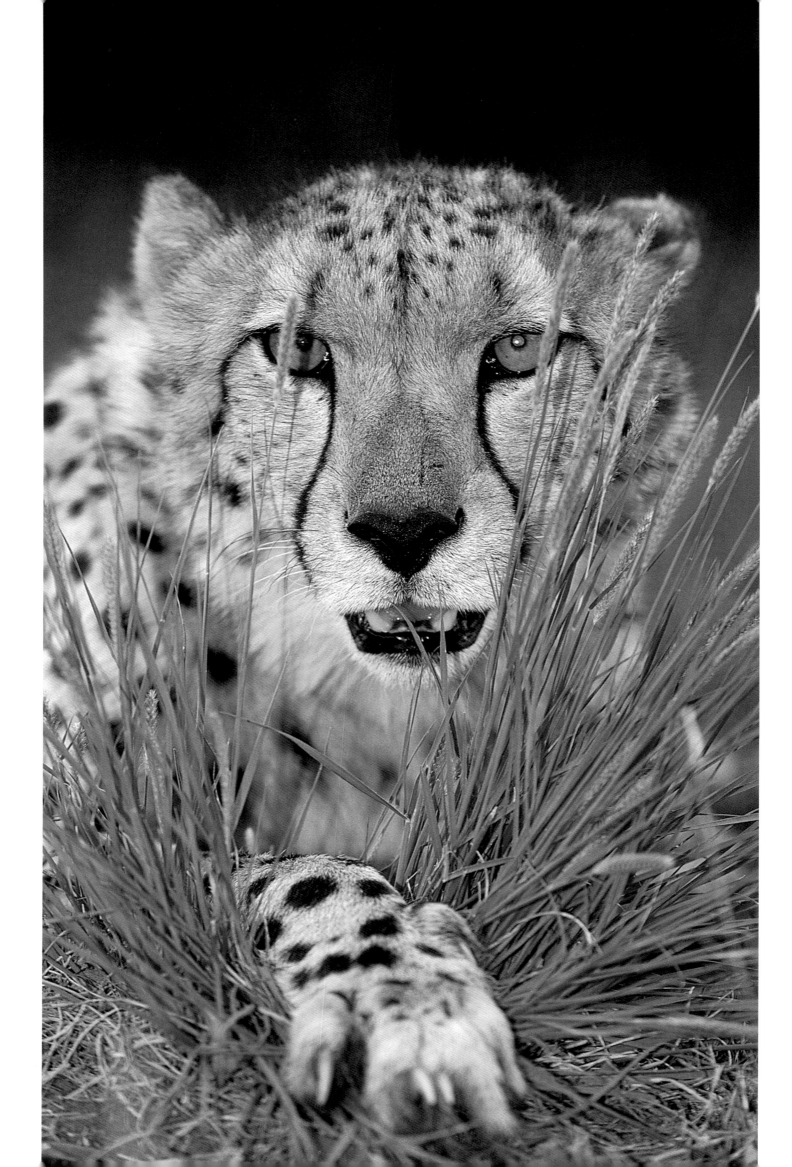

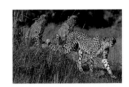

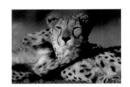

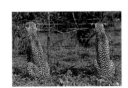

ON A PROJECT OF THIS MAGNITUDE there are always people, friends and family who deserve one's utmost gratitude. So as not to detract from the importance of them all, I've had to single out those people who, some of them unwittingly, have particularly influenced me in one way or another.

I've been privileged to have had a number opportunities present themselves to me in my life. Not only is it important that the opportunity present itself, but the timing is of equal importance. If mentally we are not up to the occasion, the door of opportunity will close just as quickly as it opened.

The difference between 'taking' and 'making' an image seems a pretty simple concept, but in reality it takes an enormous amount of experience. I've been very fortunate in having had the opportunity to work with my good friend, Chris Johns, who unselfishly parted with his support and advice. Chris not only shared the technical aspects of photography, but also taught me a tremendous amount about the subtleties of the job. I feel privileged to have had the opportunity to spend so much time in the field with someone who knows more about creating images than many of us can ever dream of.

Pushing the envelope is nothing new for me, not in a reckless sense, but more in the sense of testing limits. It is these restraints that were shattered by another inspirational person, Kenji Yamaguchi. It is an honor to have the privilege of working with and then becoming friends with such people who know no boundaries, where everything is a challenge. In today's world with technology at out fingertips it is more about applying what we have rather than merely using it.

The years spent travelling and working on this book would not have been possible without the help of special friends. Not only were we accommodated and fed, but often motivated by their inquiring minds: Mike Holding, Tania Jenkins, Mike and Hannelize Reddin and the Schrams, Alain and Illona, are those that stand apart.

A special mention has to go to those that enabled me to continue with my career when an unfortunate incident with a puff adder almost cost me my arm. As far as I know there are not many one-armed photographers running around. I owe my entire career to Alison Brown and Dr Steven Reed who on that fateful day came to the rescue and by their timely intervention, ultimately saved my arm. Dr Edwards and the entire ICU and trauma staff at Milpark Hospital also deserve special mention for their high-quality professional medical attention.

The amount of gratitude that needs to be expressed to my greatest source of inspiration has no measure. To 'my girls', Hélène and Michelle who have to endure those long and lonely months when I'm out in the field, this is all for you.

DAVE HAMMAN

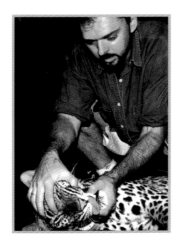

MY WORK WITH CHEETAHS BEGAN AT PHINDA and I am grateful to many people there for their enduring support and interest. In particular, my thanks go to John Skinner (University of Pretoria), Kevin Leo-Smith and Dave Varty for the opportunity to work on reintroduced cheetahs, and to Les Carlisle, Gus van Dyk and Martin Rickleton for teaching me how to catch them. Many rangers and trackers have provided information on the Phinda cheetahs over the last decade; in particular, thanks to Gavin Lautenbach, Tina Martin, Bryan Olver, Kev Pretorius, Karl Rosenberg and Carl Walker. A great many more people have helped with their time and valuable input over the years on cheetah matters; there are too many to name here but special thanks to Lise Hanssen who helped to establish Africat, and to Laurie Marker of the Cheetah Conservation Fund. To Eve Gracie, thank you for asking me to write about cheetahs and much more besides.

The early chapters benefited enormously from the input of many people. David Coulson from the Trust for African Rock Art, Anthony Ham, Lajos Nemeth and András Zboray provided excellent information on cheetahs in ancient art, and thanks also to Lajos for information on cheetahs in North Africa. I am indebted to the many respondents to my queries on the practice of hunting with cheetahs; in particular, thanks to Miriam Bibby, (Ancient Egypt Magazine), Lee Fitzhugh (University of California), Mostafa Saleh (Al Azhar University), Mohamed Nour-Eddine Fatehi (Moroccan Falconer's Association), Derek Welsby (British Museum) and Kelly Wilson (DeWildt Wild Cheetah Project). A special thanks goes to David Witts whose encyclopaedic knowledge of difficult-to-find literature is second to none and saved me from a number of early errors. I am grateful to Harold Bryant of the Royal Saskatchewan Museum for his insight on extinct carnivores and to Anne-Marie Drieux (Fonds de Conservation du Guepard) for supplying information on the desert cheetahs in Mali. My thanks also to Kate Crough and Andrea Gill for their terrific work under pressure to scan my illustrations and make sure they reached Cape Town.

At Struik, Pippa Parker offered me the wonderful opportunity to work on this project; her constant enthusiasm has ensured that it proceeded in sometimes difficult circumstances. Special thanks also to Helen de Villiers and to Roxanne Reid for their interest in cheetahs, attention to detail and extremely speedy work. Janice Evans' work on designing the book has been exeptional under very demanding deadlines. The beautiful end result is a credit to her dedication. Dave Hamman's love for the subject and readiness to accept my ideas throughout has been a complete pleasure. Finally, my text draws heavily on the findings of many other cheetah researchers for which I am very grateful. Any errors in interpretation are entirely my own.

LUKE HUNTER

10:15: The female cheetah Mahamba is resting with her five young cubs in the shade of some jackalberry trees. Mahamba is suddenly alert and I see she has spotted a single male impala moving slowly through thick woodland about 60 metres away; he is unaware of the cheetahs. The bush is extremely dense, less than ideal for a chase, yet Mahamba begins stalking. She is achingly careful about each step and it takes her 30 minutes to cover 15 metres; I have never seen a stalk like this. 10:45: The impala looks directly at Mahamba. She is frozen, completely immobile. They stare at each other in a stalemate for a minute before the impala moves off slowly. He has not recognised the danger. Suddenly, Mahamba takes off. She hurtles into the bush and disappears. I catch a glimpse of the impala in full flight, with Mahamba close behind. It is impossible to follow her, so I wait with the cubs. They are very alert, all sitting upright, listening. At 11.10 (24 minutes later), I hear Mahamba call in the distance. One cub chirps loudly in response and Mahamba calls again; as one, all five cubs race off toward the calls. I relocate them five minutes later. Mahamba has killed the impala (a five- to six-year-old male) and the cubs are feeding. I am astonished at how dense the bush is here. Cheetahs must be more versatile hunters than widely depicted.

This hunt took place in the Phinda Game Reserve, a small privately owned reserve in the humid, closed acacia woodlands of South Africa's northern KwaZulu-Natal Province. In 1992-1993, 17 cheetahs were reintroduced into Phinda after the last resident population had been wiped out in 1941. One of the released cheetahs was the female I came to call Mahamba (pictured right). Saved from a farmer's bullet in central Namibia, she went on to have 16 cubs at Phinda before, in advanced old age, she was killed by a leopard four days before Christmas 1996.

Throughout this book, direct observations of Mahamba and the other Phinda cheetahs illustrate the species' unexpected versatility: their ability to hunt in dense habitats, their prolific reproductive potential, their skill in taking large prey, and more. Alongside the field notes, the book compiles observations from throughout the cheetah's distribution, ranging from the 34-year-old exhaustive study of Serengeti cheetahs headed by Sarah Durant and Tim Caro, to fleeting glimpses of the last remaining Asiatic cheetahs in Iran. We hope to answer some of the common questions about the cheetah, overturn myths and provide some insight into what makes the cheetah tick. Why do males form coalitions? Are female cheetahs poor mothers? Do cheetahs kill people? And, most importantly, is the species headed towards extinction?

Above everything else, we hope that this book inspires. Cheetah mothers like Mahamba successfully provided for their cubs for millions of years before modern humans appeared on African savannahs. But the pressure of an expanding human population now threatens their continued survival, and cheetahs need our help. Whether it is donating time or money to field conservation projects, writing letters to governments, or simply visiting the game parks and reserves where cheetahs survive, the actions of people will determine the cheetah's fate in the next century. Of all things, let this book not be a memorial to the last of the sprinting cats.

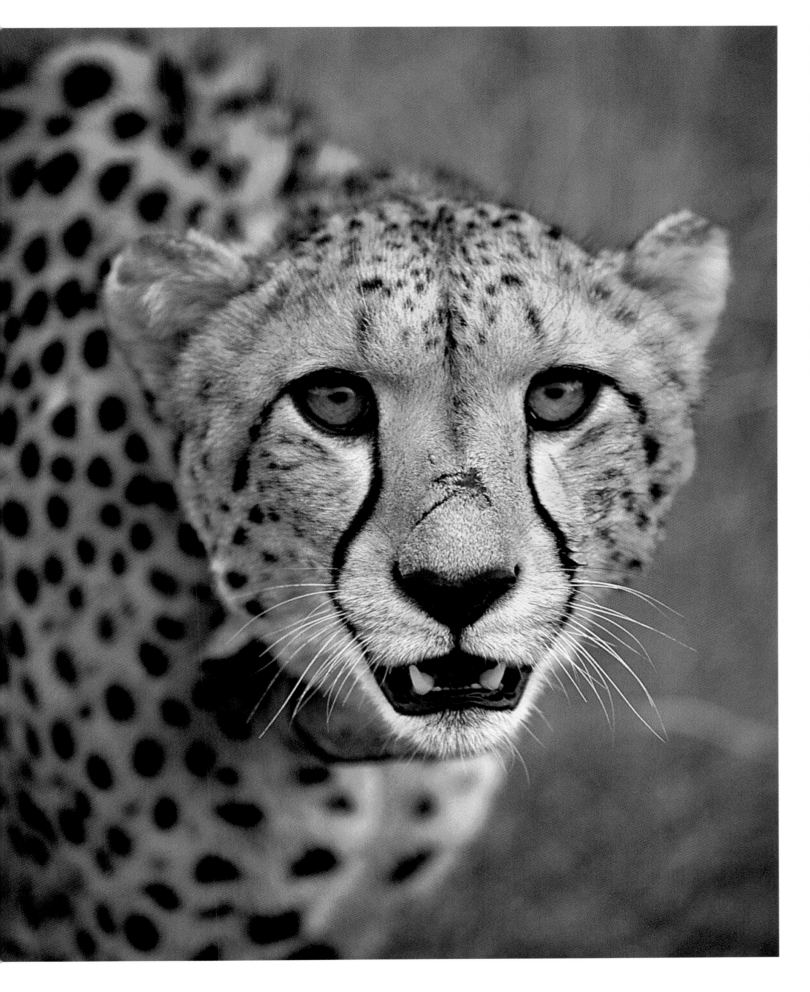

time of the great Mughal emperors in the 16th to 18th centuries, it was practised on a scale that no culture has equalled. Probably the greatest practitioner the world has seen was Akbar the Great, who ruled from 1556 to 1605. His son, Jahangir (himself a devoted hunter who once caught 426 antelopes with cheetahs in a hunt that spanned 12 days) reported that at one time Akbar had 1 000 cheetahs in his hunting stables. Over his 50-year reign, Akbar is recorded as having owned 9 000 cheetahs.

Like those earlier cultures that had practised hunting with cheetahs, the Mughals captured them as adults. They recognised that cubs were not equipped with the skills to hunt, and except for a single litter of three born during Jahangir's reign, never succeeded in breeding them. Cheetahs were caught by means of deep pitfall traps dug in game trails they were known to use – a method that occasionally resulted in the cheetah breaking its tail or leg. Akbar, whose personal interest in the cheetah was peerless, refined the technique by digging shallower pits and devising a sophisticated trapdoor that closed after the cheetah was caught. His method eliminated the problem of injuries and ensured that the cats could not escape. The Mughals also caught cheetahs by running them to exhaustion on horseback, or by laying snares of deer-sinew around 'favourite trees'. Intriguingly, the latter method is echoed in the modern practice of setting cage traps around play-trees, the most widely used technique to trap cheetahs in Namibia today (*see* Chapter 6, page 124).

Because it was always adult cheetahs that were procured, they were already skilled hunters, yet all newly caught cheetahs underwent a period of training. The training served primarily to tame the wild animal and habituate it to the process of hunting with people rather than actually teach it to capture prey. Even so, cheetahs in training were commonly loosed on antelopes that had been deliberately injured, as though they required practice. In any case, most cheetahs were ready to be taken hunting within three to six months, though it sometimes took up to a year and Akbar is credited with refining the training period to just 18 days.

The Mughals transported cheetahs to the hunt on small carts drawn by bullocks, a practice that had been adopted by numerous cultures before them and persisted after. The method exploited the indifference of many ungulate species to bullock carts, which were ubiquitous among peasants throughout Asia and represented no threat (unless, of course, they carried a cheetah!). In parts of India, Iran, Syria, Mongolia, Kazakhstan and Europe, cheetahs were also carried to the hunt on horseback, having been trained to sit behind the saddle, sometimes on a flat seat or a small rug specially designed for them. In the dying stages of the sport in the early 20th century, motorcars were used to ferry cheetahs to the hunt. Whatever the transportation,

CHEETAH ATTACKS ON HUMANS

The Mughals and others subdued wild cheetahs using nets, ropes and their bare hands, yet there are no records of a cheetah ever killing a captor in self-defence. In fact, there is no record of wild cheetahs ever killing a human at all. Tame individuals occasionally maul people, particularly children – a toddler attacked by a pet cheetah in Namibia was clinically dead for some minutes before a family member revived him – yet there are no verifiable accounts of even children being taken by a wild cheetah.

Given that cheetahs can kill prey considerably larger than people, there is little doubt that they could overpower a human if so inclined. That they do not is probably due to a combination of factors, particularly the cheetah's reluctance to confront large predators and its preference for gazelle-type prey (*see* Chapter 5, pages 88–115, for details on diet). As upright, group-living, large-bodied hunters, humans are both too dangerous and too different to be on the cheetah's menu.

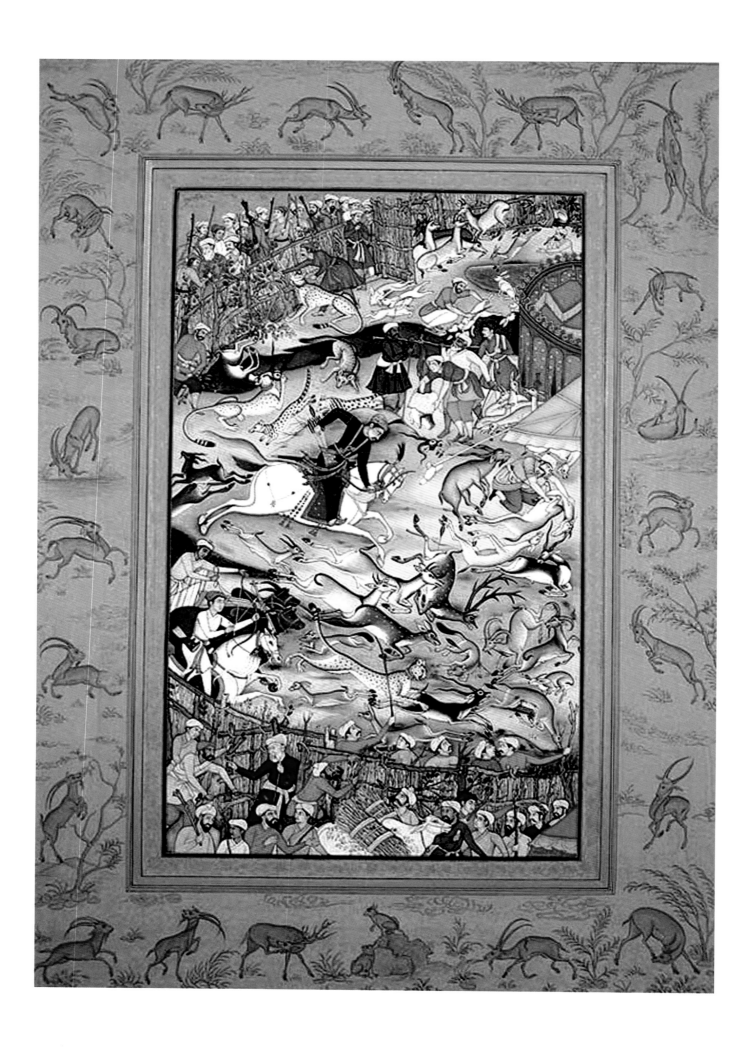

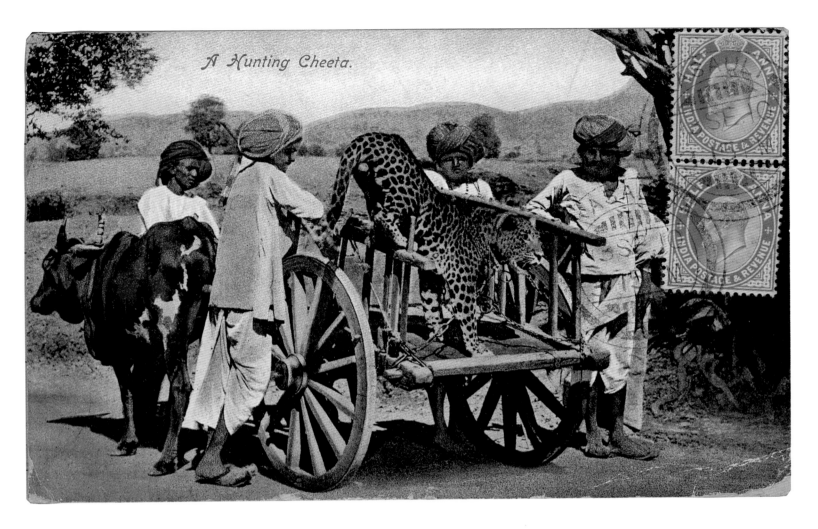

A Hunting Cheeta.

cheetahs were routinely blindfolded until they reached the quarry. The practice was adapted from falconry in which the hood serves to keep the bird calm, though whether it made a difference to cheetahs (which, once tamed, are less highly strung than raptors) is not recorded. Some cultures kept their cheetahs blindfolded constantly, except when they were hunting or being exercised.

On sighting a herd of antelopes, the hunters adopted a number of different tactics. The most common and straightforward method entailed a careful approach to within a reasonable distance from the quarry (usually recorded as the equivalent of 100 to 300 metres), whereupon the blindfold was removed and the cheetah set free to begin the chase. However, the Mughals employed a number of variations, knowing each by specific terminology. They positioned the cheetah downwind of the herd and then moved the cart in the opposite direction, drawing the attention of the prey while the cheetah stalked. They also lay in wait with many cheetahs while beaters drove prey towards them and then loosed the cats as the herd was upon them, often making many kills. Finally, cheetahs were also used in *shakhbandh*, great stockades created of branches and trees that hemmed in the prey.

When the cheetah captured its target, handlers rushed to slaughter the prey according to halal, and rewarded the cheetah with a small bowl of blood or some of the internal organs. Non-Muslim cultures also typically removed the cheetah from its catch, perhaps so that it could be hunted again or possibly to

Above: A unique photograph from around 1900 showing a tame adult male leopard being transported in the manner normally reserved for trained cheetahs (and wrongly labelled as such). Leopards are not nearly as amenable to human contact as cheetahs and it is likely that they were kept like this on very rare occasions.

Opposite: *Depiction of a* shakhbandh *hunting scene at Akbar's court. The very accurate portrayals of species provides valuable information on which animals were hunted with cheetahs. Here, as well as the favoured Indian blackbuck, the cheetah's quarry includes chinkara, chital, markhor, nilgai, urial and hares.*

(Miniature Painting on Paper by Kailash Raj. By kind permission of Exotic India, www.exoticindia.com)

retrieve the trophy's skin before it was damaged. The main quarry was the black-buck, a member of the gazelle tribe endemic to the Indian subcontinent. Male blackbucks were more sought-after trophies than females. Indeed, the Maharajas who continued with the sport after the downfall of the Mughal Empire apparently trained cheetahs to select only males by withholding their reward for a kill if they took a female. Supposedly, cheetahs learned to kill only male blackbucks within six months. Other species that were hunted included the chinkara (a small Asiatic gazelle) and, less often, the large Indian nilgai, as well as wild goats and sheep such as ibex, markhor and urial. Paintings of the *shakhbandh* hunts show many small carnivores such as civets and foxes caught up in the drive, but these were probably not intended as targets for the cheetahs. In the Central Asian republics of the former Soviet Union, goitered gazelles, foxes and hares were hunted with cheetahs.

Hunting with cheetahs declined with the demise of the Mughal Empire in the early 1700s, though it remained popular with Indian nobility until very recent times. With the occupation of the region by the British, both the sport and the cheetahs were consigned to oblivion. The British were largely uninterested in coursing with cheetahs – somewhat ironic given the fact that they called the cheetah the 'hunting leopard,' a name derived from the sport. Instead, wildlife was fair game to the British and they hunted wild cheetahs assiduously, usually by rifle but sometimes by spearing them from horseback or setting dogs on them. British India also imposed bounties on cheetahs from 1871 (and possibly earlier), when the cheetah was already scarce and declining. Indian royalty continued to hunt with cheetahs well into the 20th century but by 1914, the species was so rare in India that animals were being imported from Africa,

Opposite: Scene from a wall painting on plaster from the New Kingdom Tomb of Sennedjem at the Workman's village of Deir el Medina on the west bank of the Nile at Luxor. Sennedjem was an architect/artist in the Royal Necropolis. The scene shows Sennedjem's eldest son dressed as a priest, making an offering to his deceased father and mother. As a priest, he wears a cheetah skin draped over his shoulders. The tomb dates to around 1200 BC.

(© Ancient Egypt Picture Library)

HUNTING WITH CARACALS

The Mughals and other great Asian hunting cultures apparently tamed cats other than cheetahs, among them lions, tigers and leopards, but the terminology used is often ambiguous. For example, the names for cheetahs and leopards were often interchanged, so the extent to which these other species were kept is very vague. However, it is clear that the only felid (cat) other than cheetahs that was regularly trained for hunting was the caracal.

Caracals were used for hunting in India from at least the early 1300s and almost certainly earlier. The process of catching, training and hunting with them was very similar to the details we know for cheetahs, and some early photographs of hunting parties show the two species together. Caracals were sent after hares and foxes, and even up trees for arboreal squirrels, but game birds such as peafowl and partridges were the most popular quarry. One variation of the hunt entailed loosing the caracal on flocks of pigeons feeding on the ground to see how many it could kill as the birds took flight; up to a dozen is recorded, though this may be an exaggeration. Hunting with caracals persisted among Indian princes until about the same time as coursing with cheetahs.

particularly Kenya. The last records of coursing with Indian cheetahs are thought to be from around 1930; later records as recent as 1960 used African cheetahs. Coursing was still known from modern-day Turkmenistan until 1949, most likely with Asiatic cheetahs which persisted in the region until the early 1980s. Today, wealthy Arab men in Saudi Arabia, Oman and the United Arab Emirates illegally import cheetahs from Somalia, apparently with a view to resurrecting the practice of hunting gazelles on the Arabian peninsula. The widespread decline of suitable prey there makes such a revival unlikely.

THE CHANGING DISTRIBUTION OF THE CHEETAH

Ironically, the demand for live cheetahs over the centuries may have set the scene for its eventual extinction throughout most of Asia. The Mughals and Maharajas employed great networks of cheetah-catchers to secure adult animals from across their realm. Assuming the estimate of Akbar's personal tally of cheetah is accurate, the numbers of cheetahs taken from the wild between his reign and the early 20th century must have been many tens of thousands at minimum. As a species that naturally occurs at low densities, this may have been enough to trigger a decline from which recovery was impossible once later cultures devoted themselves to outright perse-cution of the cheetah and its prey. Had Akbar or his descendents succeeded in breeding them instead of relentlessly removing them from the wild, the cheetah might still be part of the Indian fauna today.

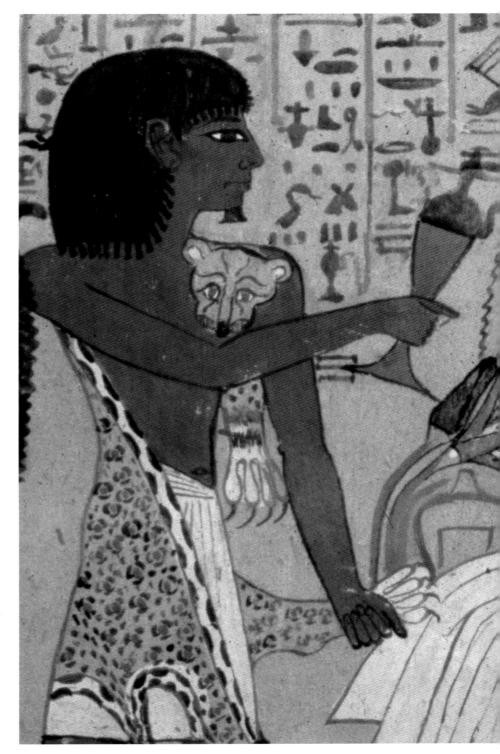

The last known Indian cheetahs were shot in 1947 by the Maharaja of Korea, a former state in the north-east of the country (unrelated to the Asian country of the same name). He encountered three young males while driving at night and shot them in his headlights, taking only two bullets: one shot killed two animals, passing through the first cheetah to kill a second standing behind it. Even for the era – one when tiger hunts were still common – both the cheetah's extreme scarcity and the wantonness of the act were recog-nised, and the editors of the *Journal of the Bombay Natural History Society* at the time published a scathing rebuke that accompanied a description of the speci-mens. Although the three males were probably not the last remaining Indian cheetahs – possible sightings continued sporadically until the 1960s – their deaths augured the extinction of the species in India.

with bones. The cheek teeth, or carnassials, which felids *have* retained, have become specialised meat-slicers and look like flattened blades that slide closely past each other in a scissor-like action as the jaw closes. *Proailurus* also had such carnassials and was certainly a strict meat-eater, but unlike modern cats it also had the rear molars.

Proailurus also resembled the miacids in its many arboreal adaptations. It had a supple, elongated back, as well as highly flexible ankles and – in contrast to all modern cats – a semi-plantigrade stance. Plantigrade species like bears and humans stand on the heel, whereas modern cats are digitigrade, or toe-standers. The overall effect in *Proailurus* was an animal probably very similar in appearance and lifestyle to the fossa of Madagascar. Uncannily feline in appearance but actually related to civets and genets, the fossa hunts lemurs in the canopy with extraordinary agility. *Proailurus* probably did likewise, targeting primitive primates, early squirrels and birds.

Fossils of the early cats are extremely rare and there are large gaps in *Proailurus'* family tree until about 20 million years ago. At this time, a new genus of cats called *Pseudaelurus* appeared, probably a direct descendant of *Proailurus*. *Pseudaelurus* had lost some of its progenitors' more primitive traits and, except for being slightly less digitigrade, is barely distinguishable from today's cats. The emergence of *Pseudaelurus* marks a turning point in the evolution of the cats. Whereas much of the world was cloaked in humid, dense forests during the time of *Proailurus*, the world was becoming cooler and drier during the late Oligocene and early Miocene. The result was the spread of open savannah and grasslands and an explosion of grazers and seed-eaters that arose to inhabit them. As the niches available to predators proliferated, *Pseudaelurus* diversified to exploit them. While some *Pseudaelurus* species hung on to an arboreal lifestyle, others became more terrestrial and more cursorial (meaning 'running'). They also grew larger and this is the first time that cats reached 30 kilograms, about the weight of a young adult cheetah. *Pseudaelurus* spread rapidly across its ancestral home of Eurasia and, during the early Miocene, entered Africa across a land bridge that appeared as ocean levels dropped in the cool, dry conditions. For the first time in its history, Africa was home to cats.

By the middle of the Miocene, *Pseudaelurus* was a genus with a number of species scattered around the world. Some species survived unchanged until about eight million years ago, but others gave rise to all the lineages of cats alive today – and some extinct ones. An estimated 15 million years ago, *Pseudaelurus* began to follow two distinct evolutionary paths. One led to modern cats (discussed below, *see* pages 34–37) while the other gave rise to the famous sabre-tooths. Erroneously called tigers (they are not closely related to tigers – a modern domestic cat is more closely related to tigers than any sabre-tooth), the sabre-tooth branch

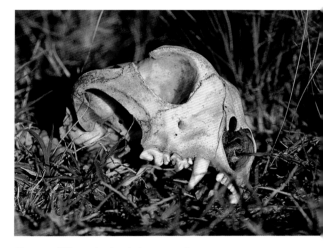

Above: *Although cheetahs are unique among felids for numerous reasons (see text), this cheetah skull shows the well developed canines and reduced number of cheek teeth typical of all modern cats.*

Below: *The fossa, probably the closest modern analogue of the early cat Proailurus. At almost 2 metres from nose to tail, with semi-retractile claws and a dentition for hyper-carnivory, the fossa fills Madagascar's 'big cat' niche. Indeed, up until quite recently, it was considered a member of the Felidae family.*

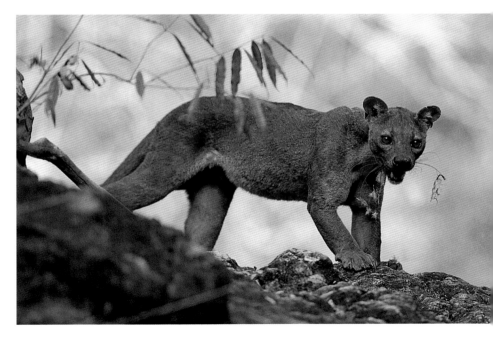

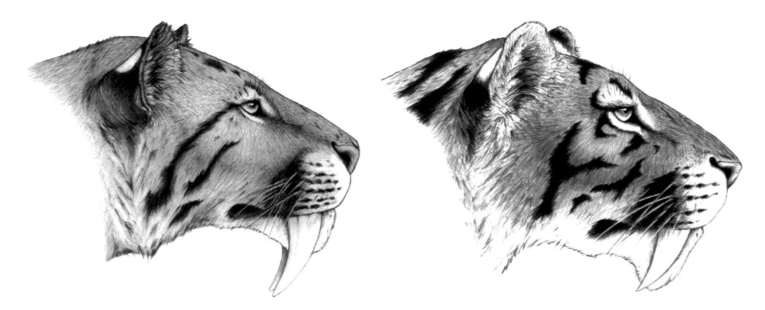

diversified into a wealth of spectacular species. The best known is *Smilodon fatalis*, the California sabre-tooth; thousands of fossils representing an estimated 1 200 individuals have been recovered from California's La Brea tar pits. *Smilodon* occurred in North and South America and survived until extremely recently; the youngest fossils are only 9 500 years old, making them the most recent survivors of the sabre-tooth branch.

The sabre-tooths also had African representatives such as *Megantereon*, a powerfully built species the size of a large, very robust leopard. *Megantereon* and other African sabre-tooths died out much earlier than the American sabre-tooths, but even so they lived for two million years alongside modern African cats. If we could glimpse an African scene from three million years ago, we would see at least three species of large sabre-tooths occupying the same range of habitats as lions, leopards and cheetahs. *Megantereon* probably chased cheetahs off their kills just as lions and leopards do today.

All living cats, including the cheetah, descend from the second *Pseudaelurus* branch. Often called conical-toothed cats to distinguish them from the sabre-tooths, they radiated into a number of different lineages, beginning many millions of years after the sabre-tooths diverged on their own offshoot. The phylogeny (evolutionary relationships) of the conical-toothed cats is still hotly debated but today's 36 species of felids are thought to be clustered into eight major groups (illustrated in the diagram on page 29). Most of the relationships are beyond the scope of this book, but of course the interesting question is: where does the cheetah fit in?

THE ARRIVAL OF THE CHEETAH

By 3.5 to 3.0 million years ago, the modern cheetah *Acinonyx jubatus* was a well established species. The global trend of gradual cooling which had kick-started the great radiation of the cats in *Pseudaelurus* had been gathering speed through the Miocene and into the Pliocene, when cheetahs first appeared. As it had for *Pseudaelurus*, the opening up of closed habitats favoured an increasingly cursorial lifestyle, one which cheetahs exploited to its evolutionary climax.

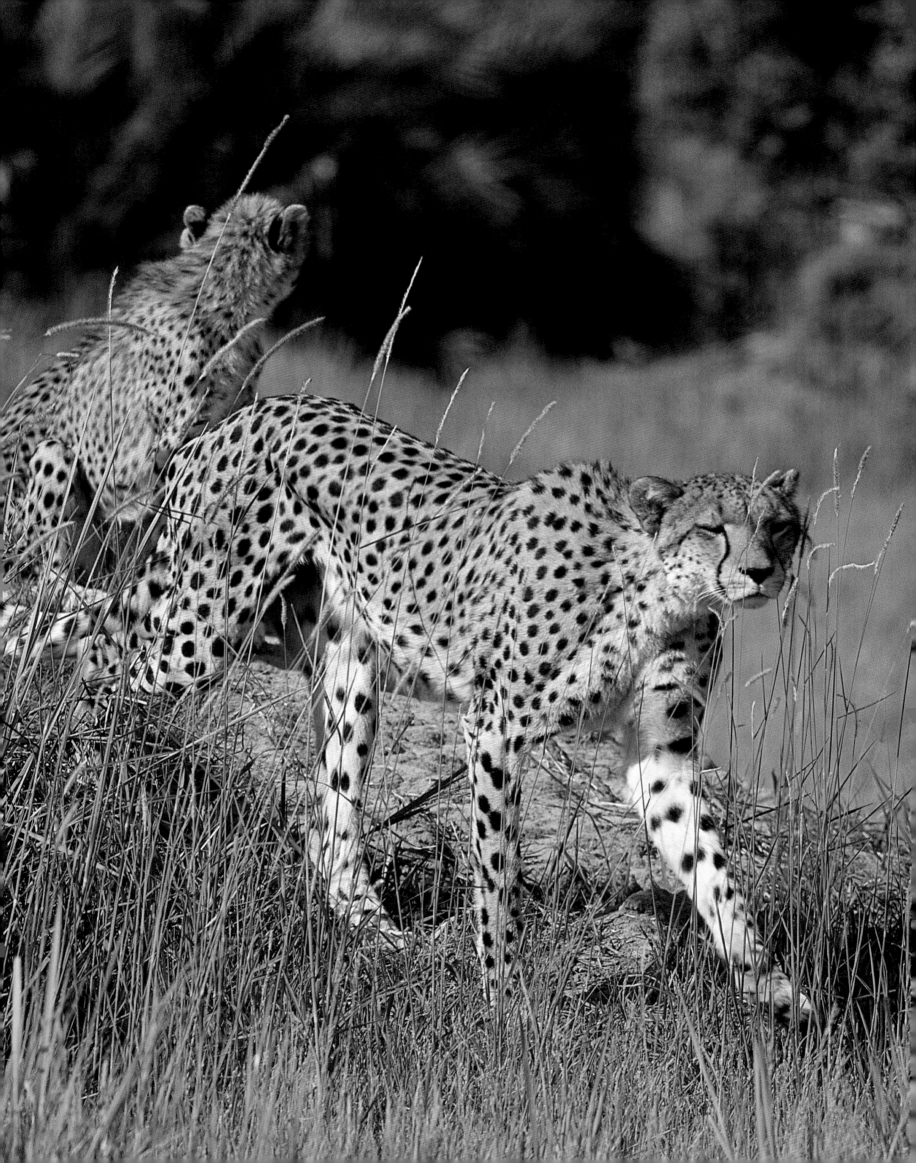

Opposite: *Cheetahs are very visual animals and constantly seek out high points like termite mounds to scrutinize their environment. Their long distance vision has never been accurately assessed but they easily discern gazelles at distances of more than two kilometres.*

Below: *Although females rarely associate with other adults, they actually spend the majority of their adult lives accompanied by other cheetahs – their cubs.*

When it comes to social behaviour in cats, the model is to go it alone. Most of the 36 species of wild felids are solitary as adults; both males and females establish their own exclusive territory and go to considerable lengths to defend it against intruders of the same sex. They proclaim their occupancy of an area with scent-marks and long-distance vocalisations, which are occasionally backed up with lethal force.

The obvious exception to the rule is the lion. The lion is the only felid in which both sexes form associations that last for life. Male lions group together in enduring brotherhoods called coalitions, usually made up of same-aged male relatives – the brothers and cousins born into a pride, who are evicted collectively as young adults – but some contain unrelated males. In the case of lionesses, their bonds are always formed between female relatives, the great resilience of which creates the core of the pride. As in solitary cats, both sexes establish territories. Lionesses defend their territories from other prides, and male coalitions exclude other males from theirs.

In cheetahs, social and ranging behaviour falls somewhere in between the highly social lion and the solitary lifestyle of all other cats. It is a fascinating, flexible arrangement that is not found in any other wild felid and, in fact, is yet to be demonstrated in any other carnivore.

THE FEMALES: SOLITARY AND NOMADIC

Female cheetahs basically follow the feline model, at least with respect to sociality. They do not form social groups with other adults and they associate with other cheetahs only during the brief period during which they are receptive to males for mating. But, unlike other female cats, they do not establish a territory. Female cheetahs never actively exclude other cheetahs from their space and therefore cannot be regarded as territorial. Instead, the undefended area they occupy is termed a home range, and each female's range overlaps extensively with those of other females. In East Africa, up to 20 females have been counted using the same area but, unlike territorial cats, clashes between them are nonexistent. Female cheetahs usually move away from other females they see in the distance, or merely ignore them.

The home range of a female may be vast. On the Serengeti short-grass plains, ranges are rarely less than 395 square kilometres and may exceed 1 200 square kilometres. In Namibia, female home ranges are even larger, reaching 1 500 square kilometres. In both populations, the same factor drives the pattern: availability of prey. Serengeti females enjoy high densities of their primary prey, Thomson's gazelles, but they are migratory (*see* Chapter 5, pages 90–100, for details about diet). The gazelles track the transient flushes of new grass that ebb and flow across the plains according to seasonal rainfall, a process that creates localised and highly mobile concentrations of antelopes. In ecological terminology, this leads to a distribution of prey known as 'patchiness'. Female cheetahs can subsist on any one 'patch' of gazelles for as long as it endures; indeed, they use areas as small as 30 square kilometres for some weeks while the herds remain. Inevitably, though, the gazelles' own resource requirements

predisposes her to being easily exploited by lost cubs. Compared to those felid species that routinely defend their territories against unrelated trespassers, the notion of attacking cubs – even strange ones – may be lacking from the evolutionary makeup of the female cheetah. Whatever the explanation, so long as the adopted cub is persistent in keeping up with its new family, it seems that the reluctant mother simply gets used to it.

THE MALES: SOCIABLE AND SEDENTARY

For female cheetahs, being solitary and nomadic is evidently the best tactic – or at least a sufficiently effective one – for meeting their needs and raising cubs. Males, however, have different requirements and pursue a very different social strategy in order to achieve them. In the same way that male lions form permanent coalitions, most male cheetahs remain in small groups for life. Numbering up to five, but most often just two or three, coalitions are generally made up of brothers born into the same litter. When young cheetahs gain independence from their mothers, the females ultimately pursue a solitary existence but the males stay together. Indeed, if a male cheetah has no biological brothers, he

Below: A female cheetah (back, right) with her five adolescent cubs, almost at the age they will become independent. The cubs will remain together as a sib-group for a few months after they leave their mother. Brief interactions between different sib-groups and females with adolescent litters explain occasional sightings of cheetah groups numbering up to 16.

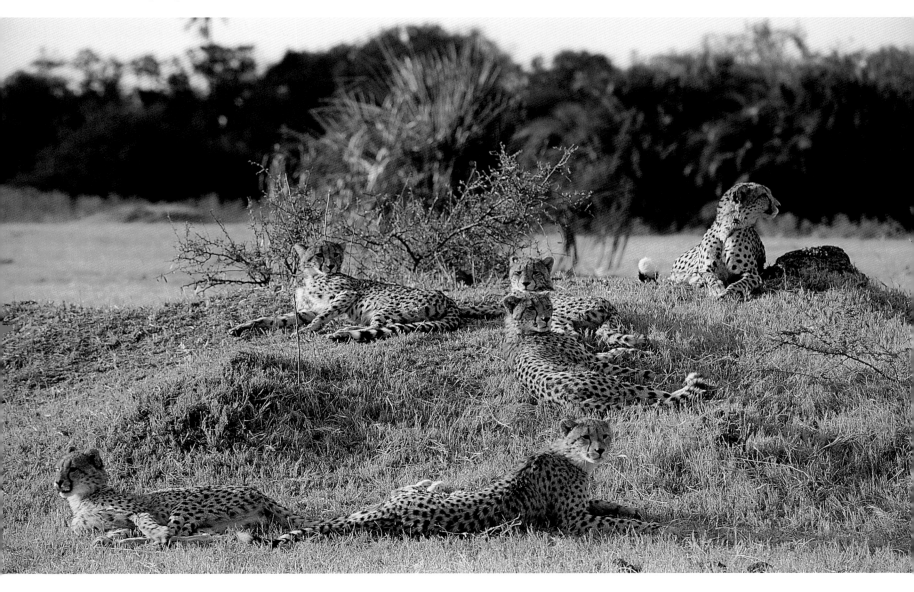

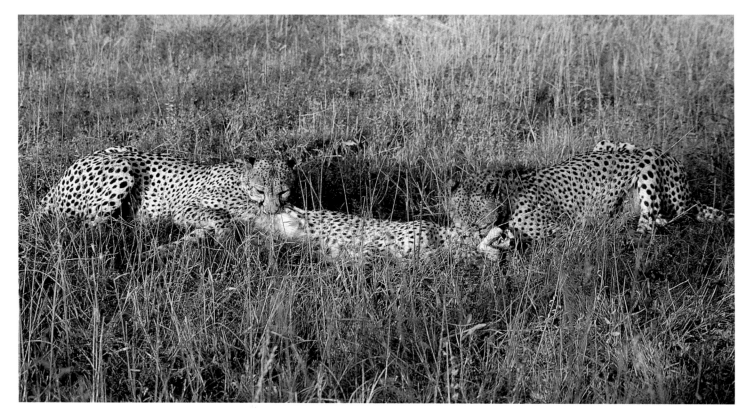

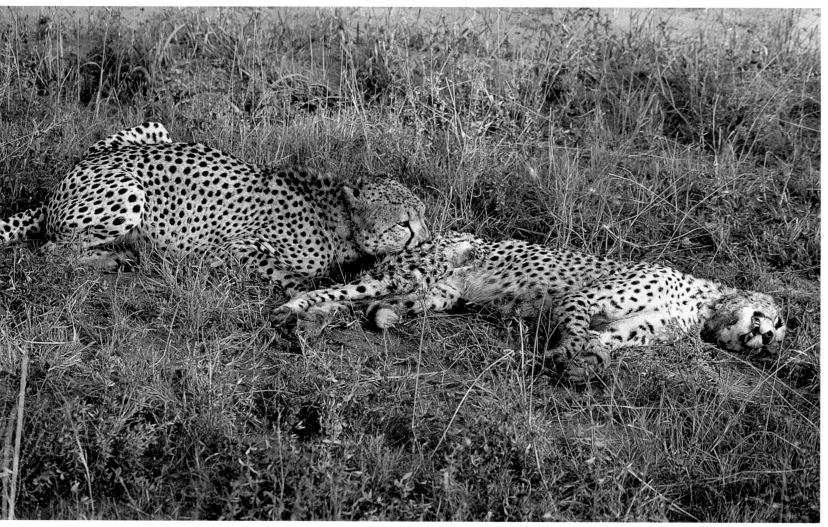

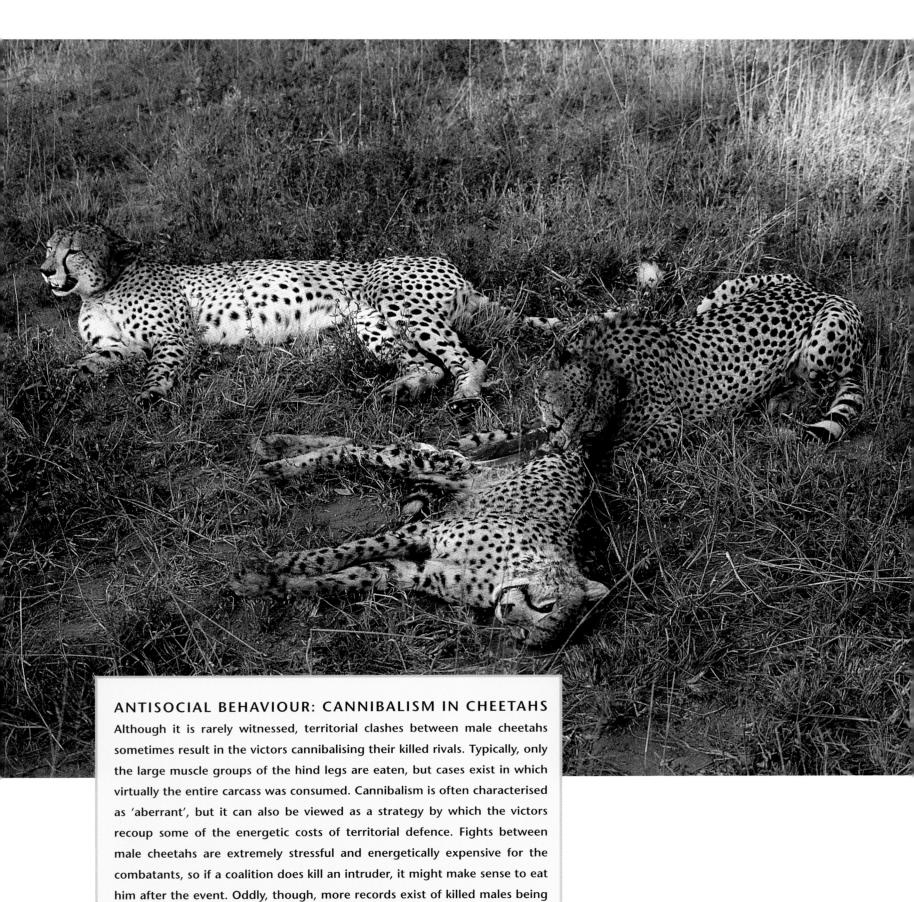

ANTISOCIAL BEHAVIOUR: CANNIBALISM IN CHEETAHS

Although it is rarely witnessed, territorial clashes between male cheetahs sometimes result in the victors cannibalising their killed rivals. Typically, only the large muscle groups of the hind legs are eaten, but cases exist in which virtually the entire carcass was consumed. Cannibalism is often characterised as 'aberrant', but it can also be viewed as a strategy by which the victors recoup some of the energetic costs of territorial defence. Fights between male cheetahs are extremely stressful and energetically expensive for the combatants, so if a coalition does kill an intruder, it might make sense to eat him after the event. Oddly, though, more records exist of killed males being abandoned than of them being eaten, so the motivation for cheetah cannibals is still open to investigation.

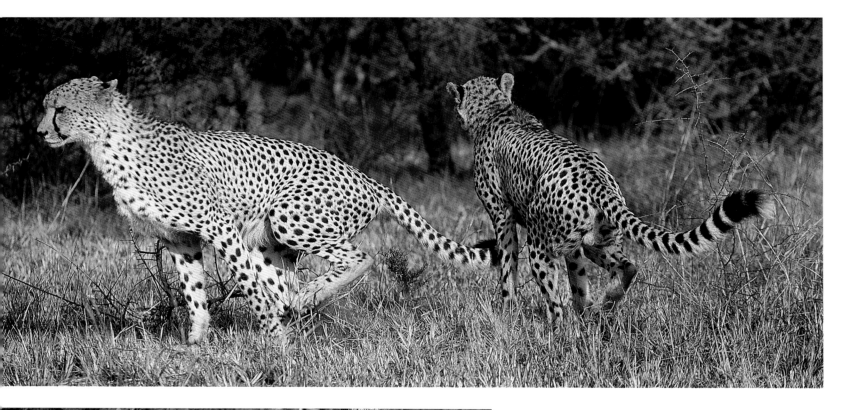

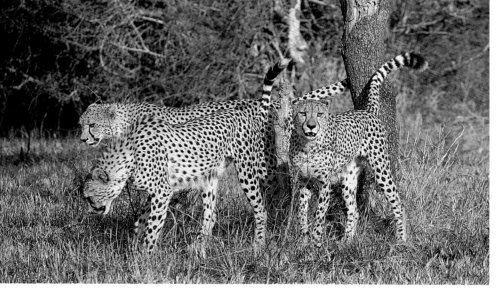

Above and opposite: Marking behaviour in male cheetahs is very ritualised, with all members of the coalition contributing to the collective smell. Urinating on prominent points takes place at a prodigious rate but defecation typically occurs only two or three times a day at early morning or evening.

may attempt to link up with unrelated males and as many as 30 per cent of all coalitions contain at least one unrelated member. Most mixed coalitions are composed of two loners who have united, but single males sometimes join an established pair and rare cases exist of a singleton being accepted by a trio of brothers.

The compulsion to be part of a coalition is a powerful one for male cheetahs, suggesting that there must be significant advantages to having companions. Easily the most compelling benefit is in acquiring territory. In contrast to female cheetahs, but similar to the males of most felid species, male cheetahs are territorial. From about the age of four, male cheetahs attempt to occupy an exclusive area that they defend rigorously from other males. Not surprisingly, the numerical advantage of coalitions gives them a significant edge over single males and, in fact, coalitions are about six times more likely than a loner to acquire a territory. Oddly, however, there is little evidence to suggest that they are more successful at holding onto a territory once they have secured it. Although singletons rarely win turf, they tend to occupy it for just as long as coalitions if they do. Regardless of group size, the average tenure is about the same, four to four-and-a-half years. There is no obvious explanation for the inconsistency. The process has been well studied only on the Serengeti short-grass plains, and studies of different populations or, for that matter, longer-term monitoring of the Serengeti males may well reveal a different pattern.

Territory holders assiduously mark their turf with urine and faeces, depositing them most often at the boundaries, but any prominent points such as large trees and termite mounds throughout the territory are invariably marked. Scent-marks inform potential interlopers that the area is occupied and other males ignore the warning at their peril (see 'field notes', right).

Fatal clashes over territory occur often enough to be a significant source of mortality to male cheetahs. After deaths by other large carnivores, they are the most likely reason a male cheetah will die in some populations. Additionally, they illustrate that the pay-offs for holding a territory must be great, certainly enough to outweigh the very substantial risks of fighting.

Not surprisingly, the chief reward for territorial males is females. Like all male cats, male cheetahs are willing to fight if it substantially increases their chance of reproductive success. For cats in which the females are also territorial, the general pattern is clear: males attempt to set up a territory that encompasses as many females' territories as possible. In solitary species such as leopards, pumas and tigers, this translates to male territories of about three to four times the size of the average female territory. Coalitions of male lions follow essentially the same process – they attempt to overlap the territories of a number of female prides. For all these species, the upper limit of the territory is determined by the size of an area that a male can successfully defend from intruders. A huge territory might encompass many females but is too large to defend adequately, whereas a very small, easily defended territory might only secure access to a single female. Where possible, male cats attempt to strike a balance somewhere in between these extremes.

For male cheetahs, there is an obvious dilemma. The females of their species do not establish small, discrete territories, and their enormous home ranges are impossible to hold against other males. However, female ranges do overlap

FIELD NOTES: MAY 27

07:05: The territorial pair, Carl and Linford, are hunting about 150 metres in the distance. A moment after I first sight them, they take off after something, but the grass is very long and I am too far away to see what they are chasing. I lose them and relocate them at 07:15. I am stunned to discover that they are in the process of killing another male cheetah. Carl is throttling the male in the manner of killing prey, only much more aggressively, and Linford is mauling the flank. They are both extremely agitated. The third cheetah is already close to death and beyond resisting, but there must have been a brief skirmish as both attacking cheetahs have deep bite wounds on their cheeks and ears. They maintain their holds for 15 minutes, by which time the third male is dead. Carl and Linford rest briefly then fall upon the dead cheetah again, attacking the carcass as though to make sure it is dead. Time after time, they continue to maul the dead cheetah, interspersed with brief rests until 08:00.

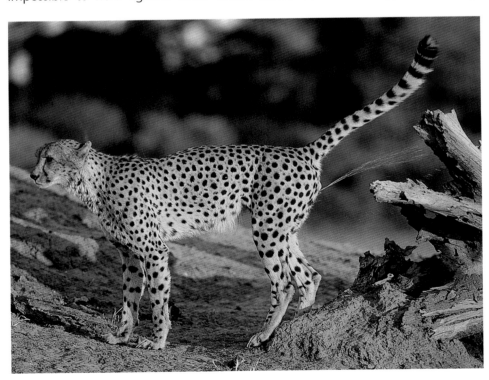

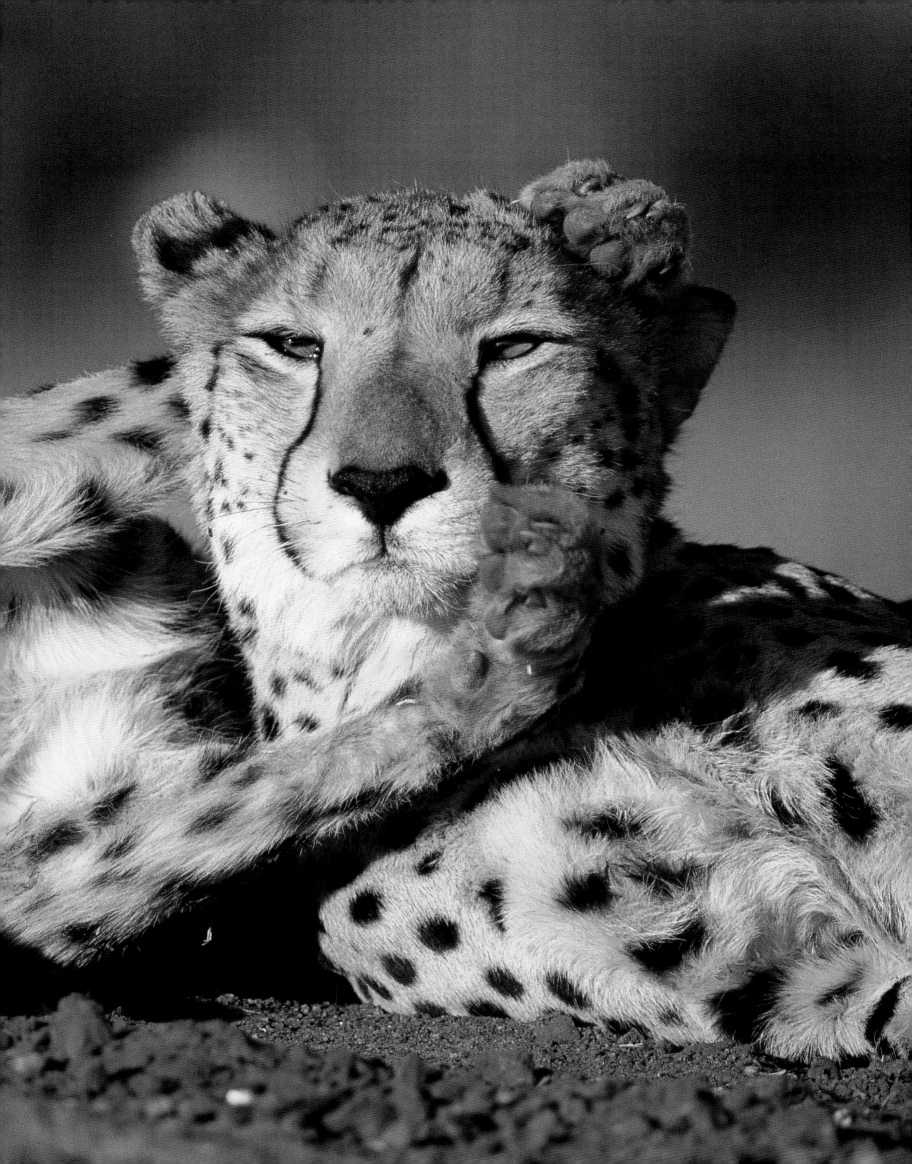

For every organism, the overwhelming biological imperative is to reproduce. Success in an evolutionary sense is determined by the number of surviving offspring an individual leaves; being the fastest, the most powerful or the best hunter is of little consequence unless those traits translate into reproductive triumph. For this to take place in cheetahs, they have to confront a number of basic challenges: they must be able to acquire or defend the resources that ensure they will pass on their genes; and, for females, they must be able to avoid predators that can kill cubs.

Despite a reputation of being somehow reproductively impoverished, wild cheetahs can be unexpectedly successful at meeting these challenges. Throughout the majority of its range, the cheetah is not threatened by an inability to perpetuate the species, and indeed, given the right conditions, is prolific. Yet although science has recently revealed a great deal about cheetah reproduction, it remains one of the least known and most contradictory facets of the species' biology. As this chapter will reveal, cheetahs rarely mate yet have lots of cubs; female cheetahs make excellent mothers but lose most litters; and, least understood of all, cheetahs consistently fail to breed in captivity yet are prodigious reproducers in the wild.

THE MATING SYSTEM

With their dichotomous social system of wide-ranging, solitary females and resident, sociable males, cheetahs have a problem when it comes to breeding – they have to find one another. Most species of large cats have a sophisticated repertoire of long-range calls that serve to advertise their presence. Both males and females use these vocalisations to warn off potential intruders of the same sex, but they also use calls to find mates. Indeed, to most human ears, the calls proclaiming territoriality and announcing sexual readiness are indistinguishable, but they clearly convey different messages to the intended audience. Lions, tigers, leopards, jaguars and pumas have come-hither calls that carry for kilometres – but cheetahs do not.

Female cheetahs in oestrus are essentially silent. Indeed, the overt signs that a female is in heat are extremely subtle. She typically loses interest in food for a day or two at the onset of oestrus and spends much of her resting time rolling pleasurably on the ground, but neither activity serves to attract distant males. Instead, cheetahs rely largely on scent marking. As a female approaches oestrus, elevated levels of reproductive hormones in her urine and faeces signify her condition, which males can doubtless detect. To enhance the likelihood of detection, she defecates on prominent sites like termite mounds, large trees and koppies – the only time a female makes such an obvious show of her presence to other cheetahs.

On finding such a signpost, males spend as long as 45 minutes assessing it, inhaling the telltale signals over a sensory depression in the palate called the Jacobson's or vomeronasal organ. Cats grimace dramatically as they evaluate a scent mark, in a characteristic expression called flehmen. In cheetahs, flehmen is very subtle but like all cats, it serves to waft the hormone-laden smells over the

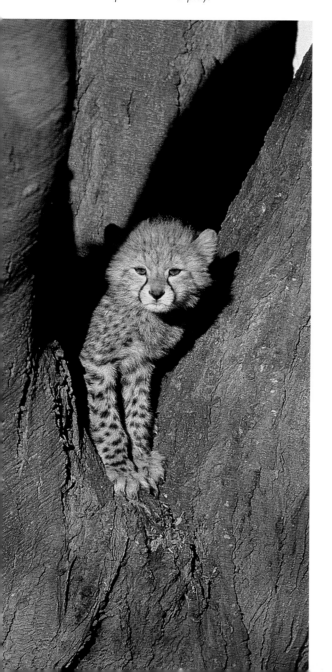

Below: *Unlike leopards cubs, very young cheetahs rarely take to trees for refuge from other predators. Most of their tree-climbing activity revolves around exploration and play.*

REPRODUCTION IN CAPTIVITY

In contrast to their wild counterparts, cheetahs in captivity suffer from a baffling combination of obstacles when it comes to reproduction. Captive cheetahs are reluctant to mate, females often fail to conceive when they do, and despite the best of care, cubs often die – around 35 per cent of captive cubs do not reach six months of age.

Initially, physiology was blamed. Male cheetahs have poor-quality sperm but this is true for both captive and wild individuals, and the latter certainly have no problem siring cubs. Attention then turned to the females, but over 80 per cent of captive females are fertile and, physiologically, should have no difficulty conceiving.

Husbandry is increasingly considered the standout issue, but even here there are no clear trends. For example, the centuries-old tradition of exhibiting cheetahs in male-female pairs is now obsolete and many zoos mimic the cheetah's social system in the wild, keeping groups of males separate from solitary females until they come on heat. The method has yielded great success with some facilities, notably South Africa's De Wildt Cheetah Centre, which has bred over 600 cubs, yet precisely the same approach – and every possible variation on it – repeatedly fails in many other institutions. The research and experimentation is ongoing.

Overleaf: *To these four-month old cubs, termite mounds make irresistible foci for play rather than for vigilance. Young cubs have excellent eyesight but they are poor at spotting danger and also make many mistakes in identification, responding fearfully to harmless species such as korhaans and cranes. By about the age of five to six months, cubs are better able to distinguish genuine danger and respond appropriately.*

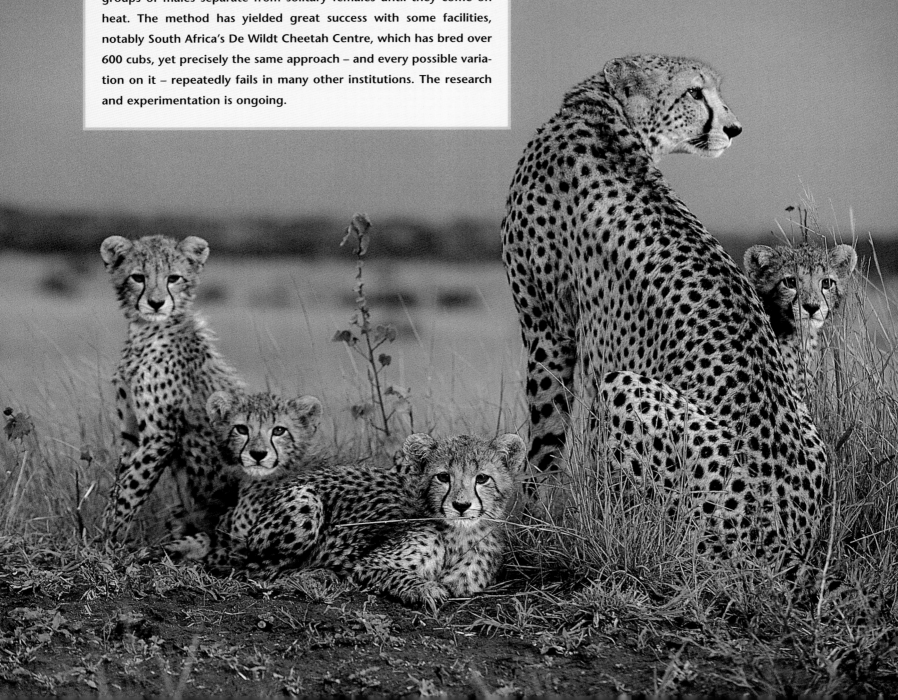

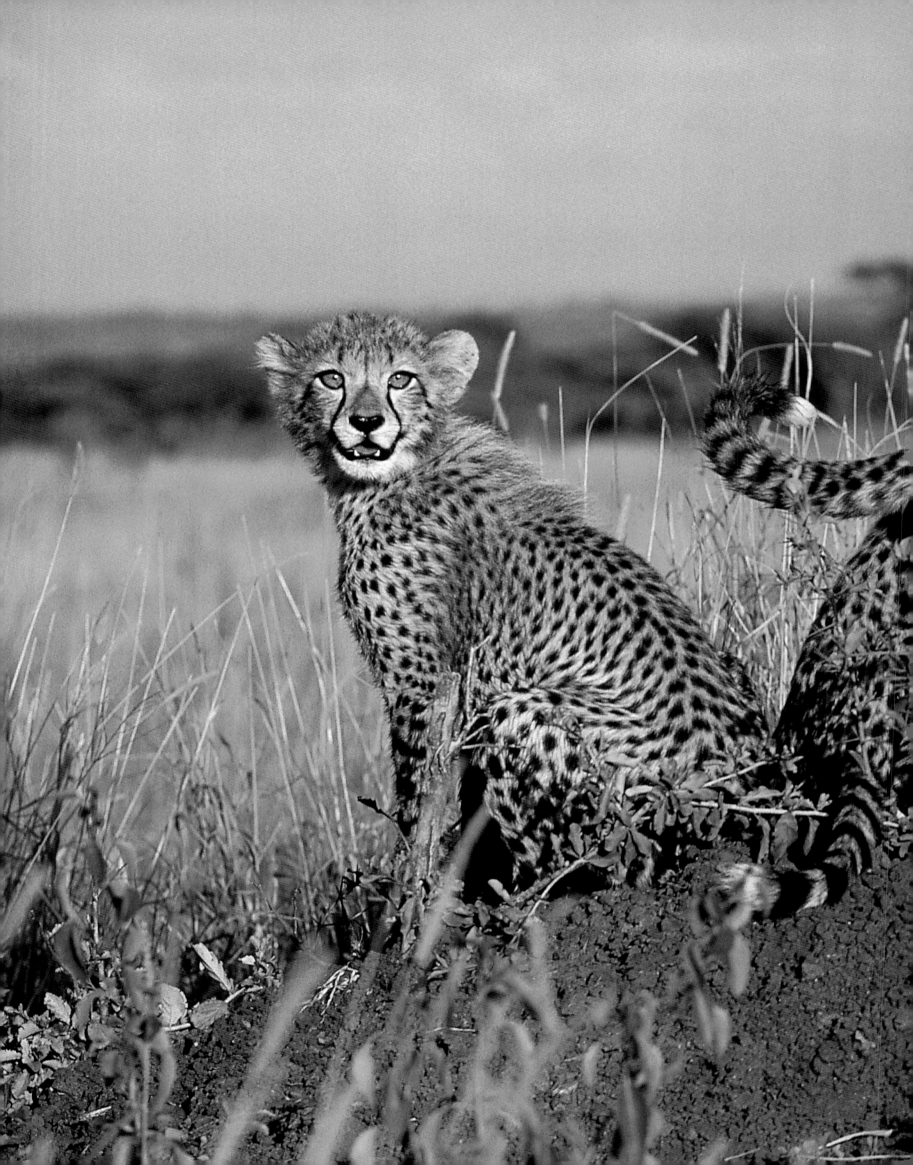

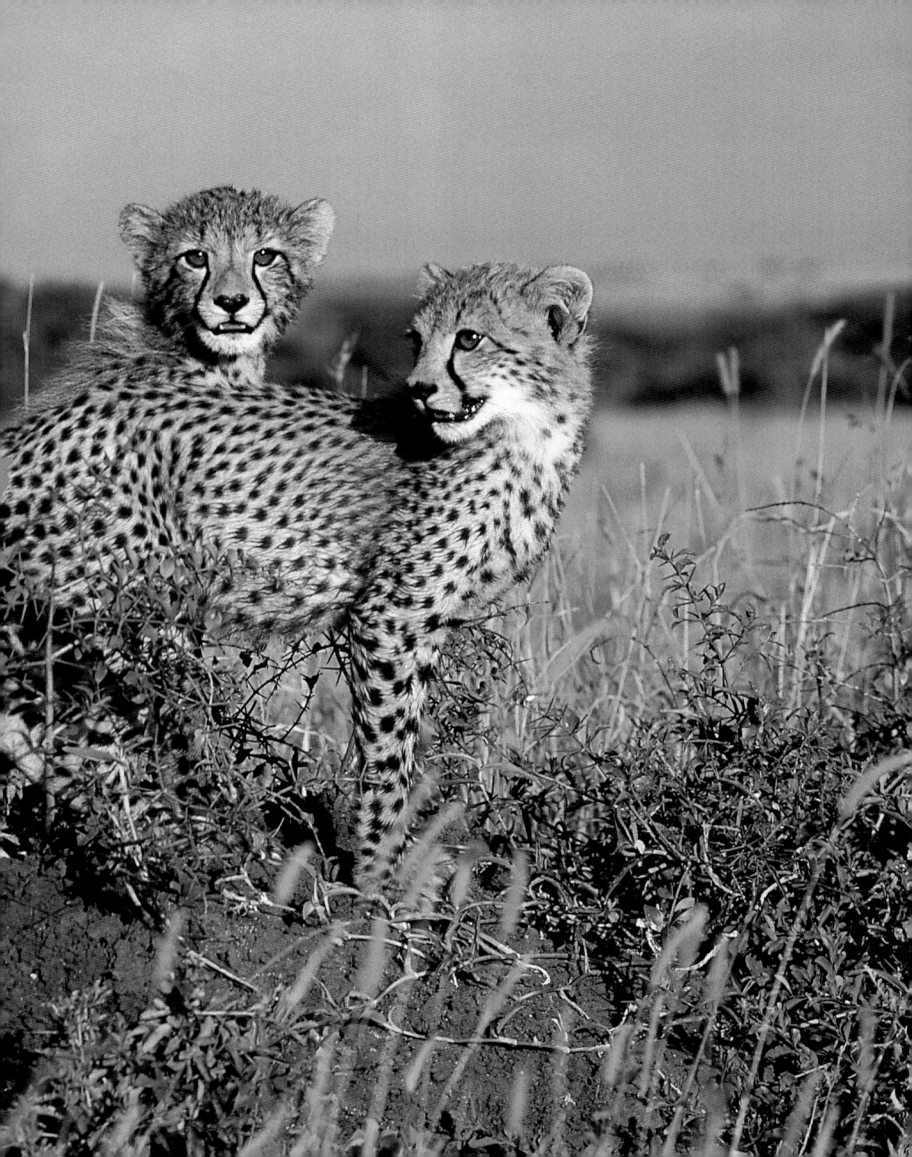

06:25: The female Mahamba is resting on a large termite mound when I see two males approaching from about 250 metres away. They have seen her and begin trotting in to explore, their postures low and aggressive. Mahamba is snoozing and fails to see them until they are about 30 metres away. She spots them and immediately takes flight, slinking down off the termite mound and rushing away, but they catch up with her in 50 metres. The lead male knocks her to the ground and she rolls frantically on her back with a shrill squeal. The second male rushes in and there is a cacophony of calls from all three animals. Mahamba remains lying on the ground, growling, yelping and stuttering at the males, who return the calls and repeatedly 'attack' her. They smack at her with their front paws and seem to bite her flanks, though none of the assaults appears serious; she is not injured. Time and again, the males attempt to sniff her hindquarters, stuttering constantly, but she protests violently each time and turns on them, provoking another spectacular round of 'fighting'. This carries on for the entire day with no indication that Mahamba is anywhere near ready to mate or that the males are losing interest.

Right: *This adolescent female is too young to be interested in finding a mate but like all cheetahs, she gravitates to high places to observe her surroundings. Like the female, the two males* (opposite) *are searching for predators or prey but unlike her, they also use high points to look for possible reproductive partners.*

Jacobson's organ, allowing them to judge the age of scent marks. Although no one has tested the cheetah's ability to discriminate smells of different ages, it is known that domestic cats can differentiate between old and fresh scent marks at the very least. Cheetahs almost certainly use the information to decide whether or not it is worth searching for the owner.

When a deposit is fresh, the males' excitement is unmistakable. They tirelessly search the area, trotting hurriedly between prominent features of the landscape and checking them assiduously for an olfactory update. Their urgency is driven by the high possibility that the female will elude them. The female habit of wandering may see her pass through a male home range in a day or two, and females display little evidence of actively searching for males. They may even avoid them; on seeing other cheetahs in the distance, females – even those in oestrus – typically lie low and show no inclination to investigate. So it falls largely to the males to find mates and they invest considerable haste in doing so. Even if they are not following the trail of a female broadcasting her readiness to mate, males will opportunistically dash over to any distant cheetah they encounter, hoping – presumably – that it is a female on their patch.

When the males succeed, the resulting encounter can be a surprisingly aggressive one, in which the female appears anything but enthusiastic (*see* 'field notes', left).

Harassment like this from the males is customary though the reasons for it are far from clear. One theory suggests that it enhances the female's receptivity by encouraging competition between the males but, in fact, virtually all the 'hostility' is directed towards the female and aggression between coalition

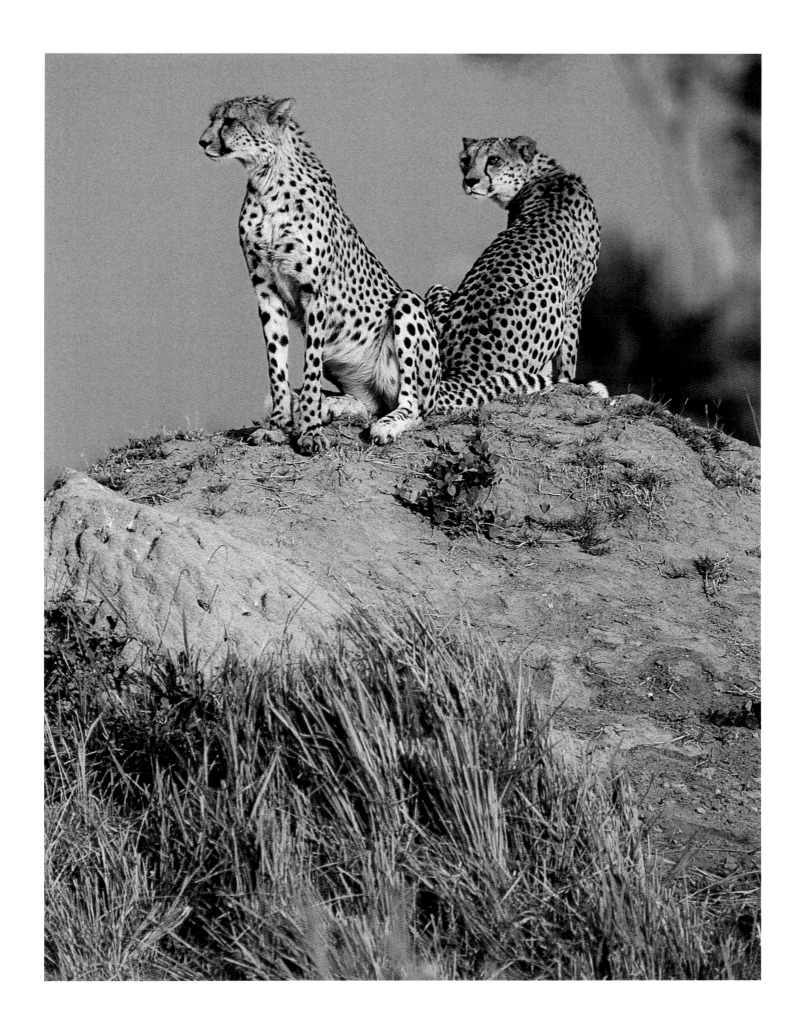

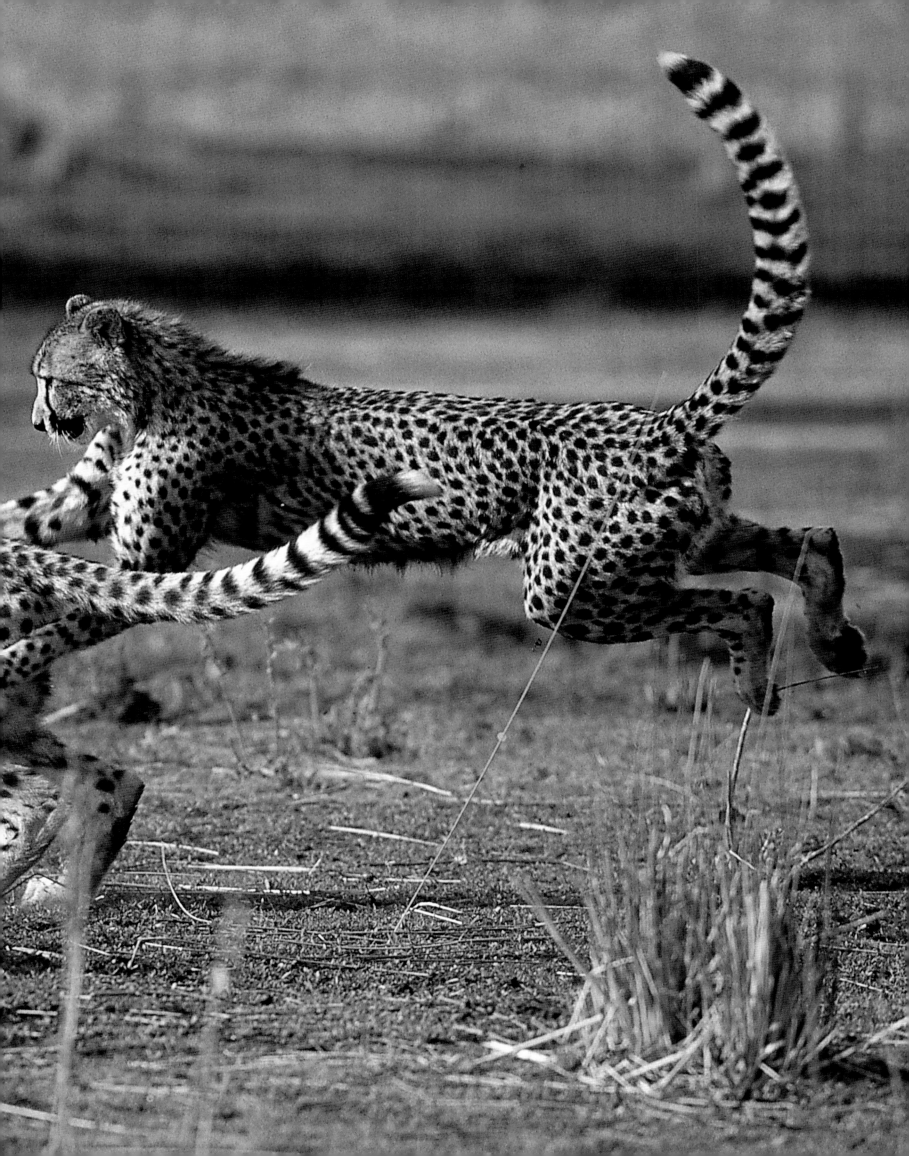

14:25: Mahamba has just caught a young impala. As her six-month-old cubs race to join her, she releases it alive (though with a large gash in its flank from her dewclaw). The lamb stumbles towards the nearest cub, which suddenly halts its approach and hisses nervously. The lamb is clearly dazed and stands immobile, with the cubs milling around, evidently uncertain of the next move. Two cubs take turns to tap it gently on a hind leg but it does not move. The cubs lose interest and sit or lie around. At one point, the impala nudges a cub in the ribs as though trying to suckle. After 10 minutes, Mahamba walks to the impala and quickly suffocates it. As though on cue, the cubs rush to the carcass and begin feeding.

Opposite: *A female cheetah (sitting upright in lower picture) assists her two cubs in tackling a young warthog. Holding back by the female as shown in the upper right photograph is typical of the 'training' process, presumably to allow the cubs to accumulate valuable experience in handling prey.*

areas surrounding the Serengeti plains. If they are anything like South African females, they are the key to the cheetah's persistence in the Serengeti. In zoological jargon, the woodland population probably acts as a *source*, enjoying high cub survival to the point that it exports individuals to the plains *sink* – a population in reproductive decline, which could not possibly endure on its own.

Life as a cub is fraught with threats, but dangerous encounters are quite rare and, if they are not resting or feeding, cheetah cubs are usually playing. Games are a furiously vigorous combination of wrestling, chasing and grappling with one another over such desirable objects as sticks, grass clumps or inedible body parts of prey like skin and tails. Play mirrors many of the behaviours that in later life are crucial for hunting and avoiding predators – for example, cubs instinctively swat at the legs of fleeing siblings in the same style that adults use to trip prey. However, the extent to which their games are a rehearsal for the serious business of being an adult cheetah is still unclear. Preliminary research suggests some advantages: cubs that often play-stalk their siblings are more likely to stalk prey species, and litters that often engage in social play are better able to seize prey released by the mother. However, whether this translates into their being more efficient hunters when it really matters has not yet been determined.

Similarly, and more surprisingly, the role of predatory training by the female in producing efficient hunters is controversial. Mothers begin releasing live prey in front of their cubs when they are as young as three months (but more commonly from about five months), providing chances for the cubs to practise their skills. However, young cheetahs can be quite inept at dealing with prey (*see* 'field notes', left).

It is hard to believe that the female's maternal encouragement holds no advantages, and although no one has ever tested the idea, cubs probably do become better hunters than if training were to be withheld. They certainly assume an increased role in suffocating the prey as they mature and possibly learn other refinements along the way, which ensures just enough competency to survive. Starvation is rare among newly independent cheetahs so, despite being poor hunters when they separate from their mother and the fact that they remain entirely reliant on her until then, young cheetahs seldom die because they cannot feed themselves.

The greatest period of improvement takes place when their mother leaves the cubs, usually when they are about 18 months old, though it can occur as young as 13 months, while some litters stay with their mothers until they are two. Mothers generally initiate the parting, typically because the reproductive imperative has come full circle and they are pregnant again. Females often conceive while they are still accompanied by large cubs but always leave them to give birth, a rapid turnaround that means females have a litter every 15 to 19 months. Compared with the similarly sized leopard (which takes around two years), it is a statistic that makes cheetahs one of the fastest reproducers among large cats.

Once their mother disappears to have her next litter, newly independent adolescents routinely stay together in a unit known as a sib-group, which remains in the mother's range. Grouping in young cheetahs increases their

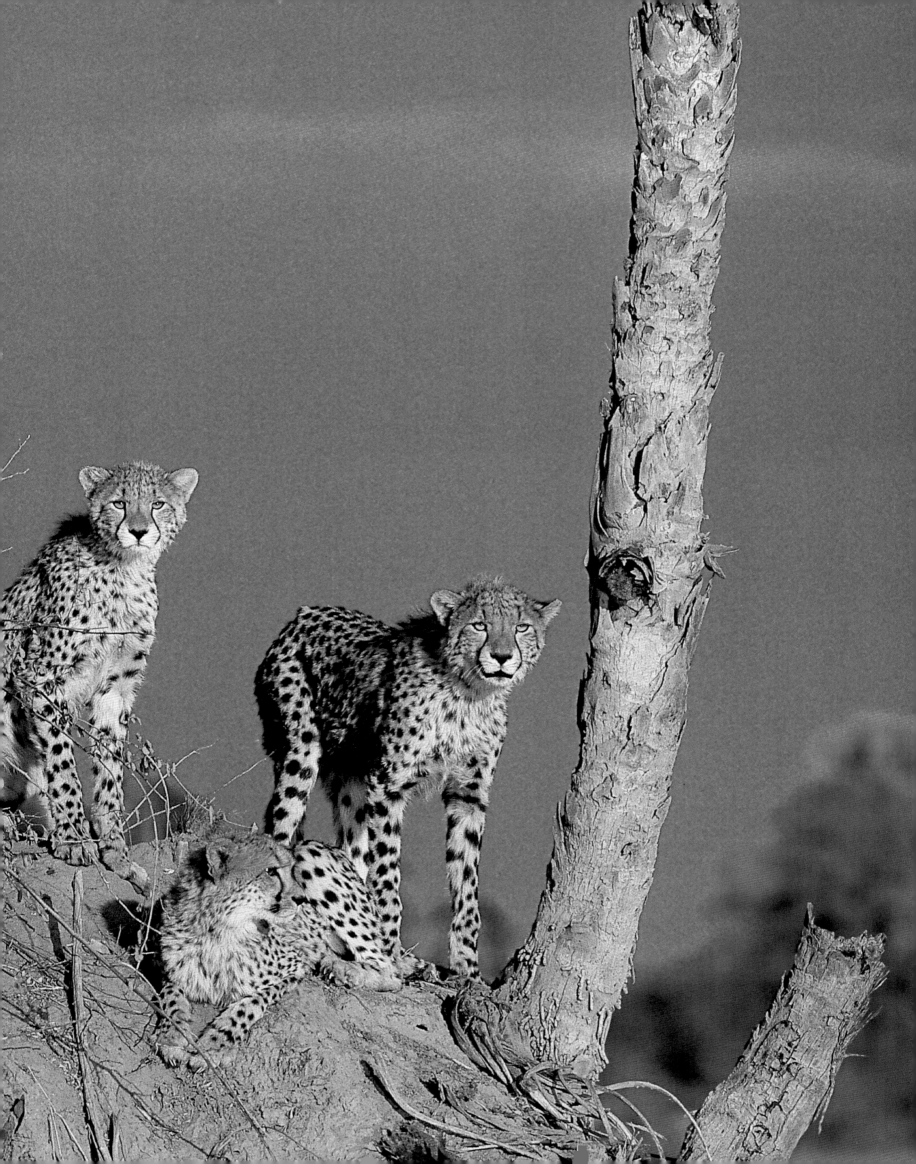

HUNTING: A DIVERSE REPERTOIRE

The cheetah is a grassland specialist and hunts gazelles; at least, that is the popular notion. It is true that cheetahs are easily observed hunting in open habitat where they often kill gazelles or similar-sized prey, but cheetahs are considerably more flexible hunters than often portrayed. Cheetahs take sub-adult zebras, adult wildebeest and even young giraffes. They hunt on the serrated slopes of Central Iran, inside the thick bush of northern Kenya and in the depths of the deserts spanning north Africa. And although the high speed chase is typical of cheetahs wherever they occur, cheetahs in different habitats have a surprising range of hunting tactics in their repertoire.

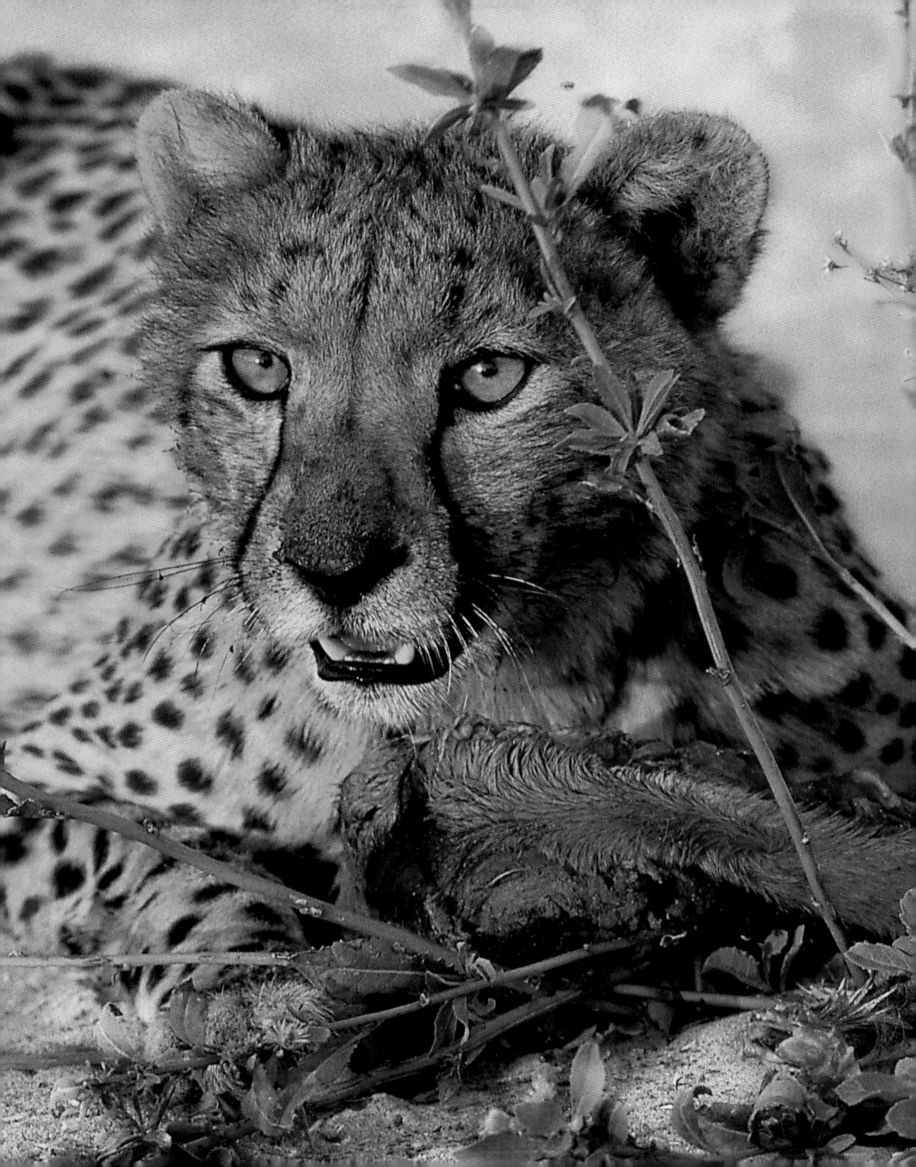

Using the cover of bushes, termite mounds and occasionally even tourist vehicles, cheetahs endeavour to move to within 60 to 70 metres of the quarry without being spotted. If cover is sparse, they drop to the ground or remain motionless whenever the prey looks up. While typically feline, the process is usually far less protracted than the classic ambush hunter's stalk; the belly-crawls and hour-long freezes favoured by leopards are rarely seen in cheetahs, and most stalks last less than five minutes. Even so, when faced with extreme conditions, the cheetah adopts an approach that has all the hallmarks of a leopard stalk. In the Sahara desert, where the absolute lack of cover often requires a painstakingly slow advance, cheetahs flatten themselves on the sand and remain motionless for long periods. Creeping forwards only when the quarry is grazing is a strategy that can bring the cat to within 30 metres of its target in daylight without being spotted. Recognising that the stalk is at least as important to the cheetah as its speed, the local Touareg nomads call the cheetah *Adèle amayas* – 'the one who advances slowly'.

Above: *Cheetahs blend beautifully with the long, dry grass typical of the African dry season. It is difficult to establish how camouflage affects hunting success in cheetahs. Given that the stalking phase of their hunting method is usually fairly brief, camouflage is probably less important to them than it is to strict ambush hunters such as leopards.*

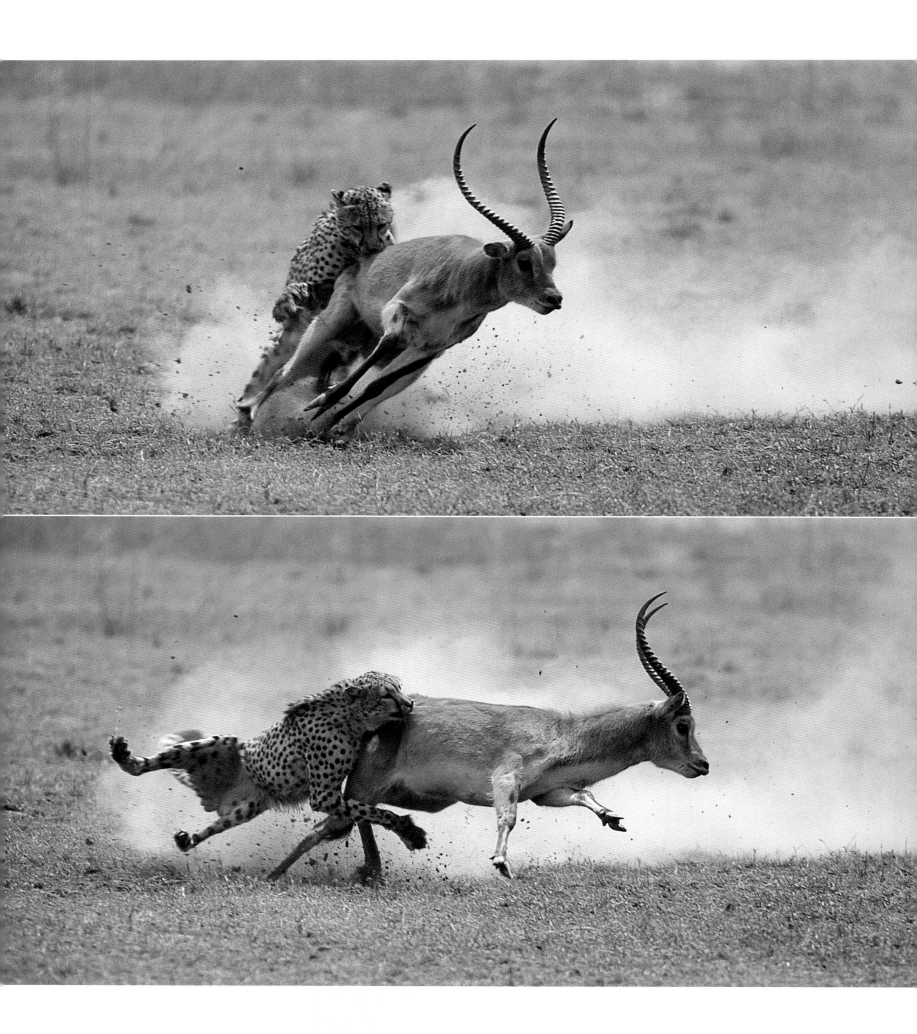

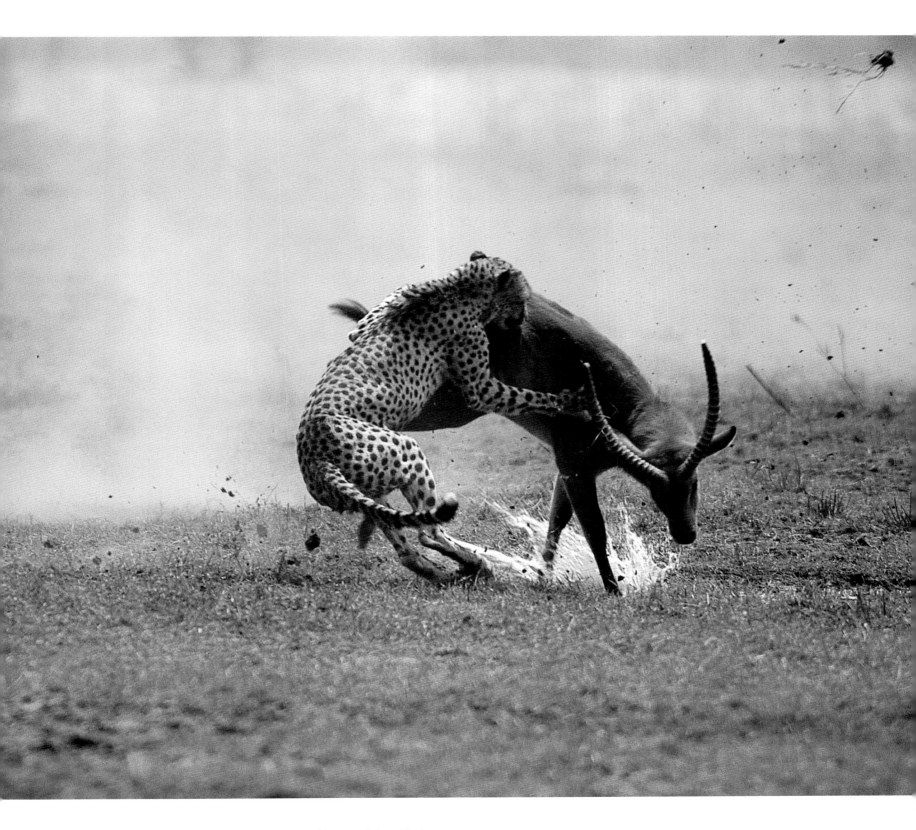

Opposite and above: *A single cheetah tackles an adult red lechwe, Botswana. Hunts such as this – where a clean takedown does not immediately result – present a very real danger for cheetahs. It would be even greater if antelopes defended themselves more aggressively. Surprisingly, a number of prey species are slow to employ their weaponry when attacked, perhaps the only reason this cheetah escaped from this encounter unharmed.*

18:45: I find three sub-adult cheetahs, two males and a female, just as they have cornered a male nyala. As I arrive, the nyala plunges into an ilala palm thicket and immediately turns to face its pursuers. It backs into the thicket and lowers its horns at the cheetahs. I am amazed to see that it is completely blind and is flailing its horns around aimlessly, presumably hoping to thwart any attack from the cats. The three cheetahs appear confused and hesitant. From time to time, they creep forwards as though to launch an attack, but whenever the bull hears movement, it slashes out viciously. It never comes close to injuring the cheetahs but it certainly keeps them at bay. After 25 minutes of this, the cheetahs move off, leaving the nyala unharmed. The departing cheetahs repeatedly glance back at the bull with somewhat bewildered expressions.

Opposite: Occasionally, cheetahs may make little effort at concealment when approaching prey and walk directly at the quarry in full view. It may be a strategy by which cheetahs 'test' prey, determining if any individuals in the herd are injured or vulnerable by alarming them into action. Even so, most kills made by cheetahs appear to be of healthy animals and more research is needed to clarify this question.

If the stalk goes unnoticed, the cheetah unleashes its astonishing acceleration. Ironically, once the hunt is set in motion, it depends on its prey taking flight to make the catch. The cheetah's technique relies on tripping its prey at high speeds, a strategy that does not require the physical strength used by lions and leopards to wrestle large prey to the ground. For the lightly built cheetah, such a close-quarter contest could be dangerous, and prey that stands its ground may diffuse the cheetah's advantage (*see* 'field notes', left).

Of course, in the great majority of cases, the prey does run and in doing so, unwittingly provides the cheetah with the momentum that does most of the work. At high speeds, the cheetah needs only to land a raking blow with its dewclaw and the target stumbles. The effect may simply be one of tripping, particularly when the cheetah strikes the lower legs, but more often the action actually pulls the prey off balance. The cheetah hooks the prey with the dewclaw and then, braking abruptly, uses its weight to wrench the fleeing quarry to one side. Almost invariably, the technique leaves a distinctive tear wound in the prey's rump or shoulder – the characteristic trademark of a cheetah kill.

Open plains and sandy deserts are ideal terrain for the high-speed chase but cheetahs exist in many different habitats and are able to modify their hunting methods accordingly. As displayed by the giraffe-hunters of Zululand, in areas where thick vegetation impedes their chances of ever reaching top speed, cheetahs use a harrying technique based on confusion and cover rather than sheer pace. Cheetahs employ a further tactic in habitats with a mosaic of open areas and scattered thickets of dense vegetation. Moving from one thicket to another, they search for hares and small antelopes like duikers and steenbok, which are flushed into the open and easily run down. Stands of long grass or low scrub are similarly quartered for small game, and here cheetahs may even use a succession of bounding leaps to lift them above the vegetation as they try to pin down the location of fleeing prey.

THE RISKS AND REWARDS OF HUNTING

Clearly, then, the cheetah is a considerably more versatile hunter than the classic television documentary portrayal, and enjoys a high success rate relative to other carnivores. Compared with an average of 25 to 30 per cent for lions, about 50 per cent of cheetah chases end in a kill. For certain prey, the figure climbs higher: nine out of ten hunts on hares in the Serengeti yield a kill, a statistic that outshines the success rate of even Africa's most efficient large predator, the African wild dog.

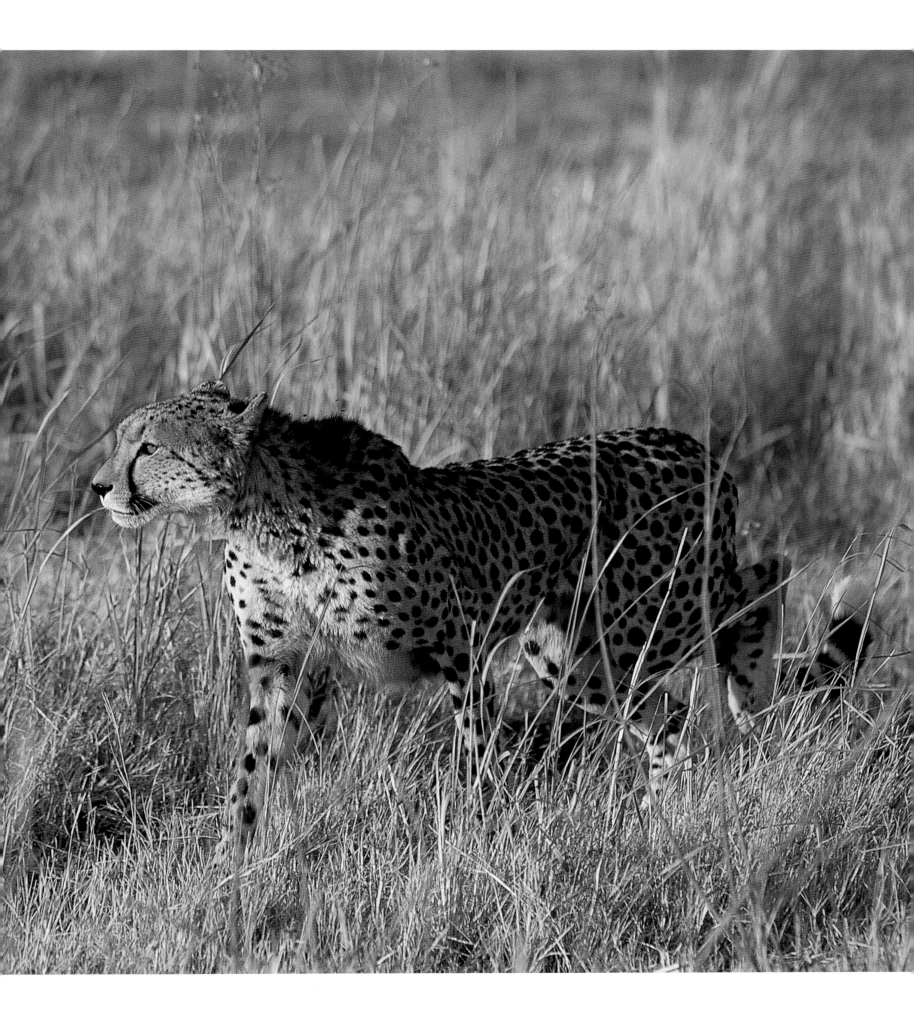

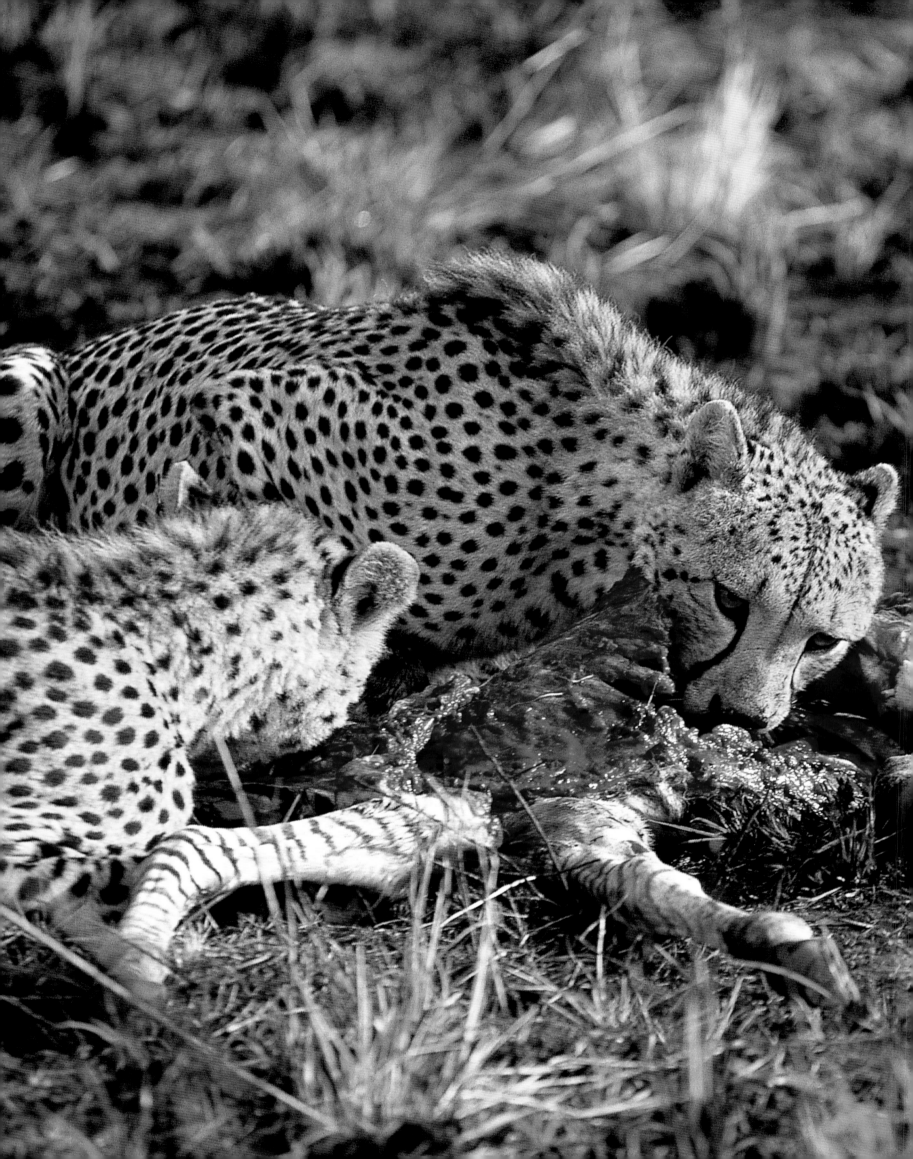

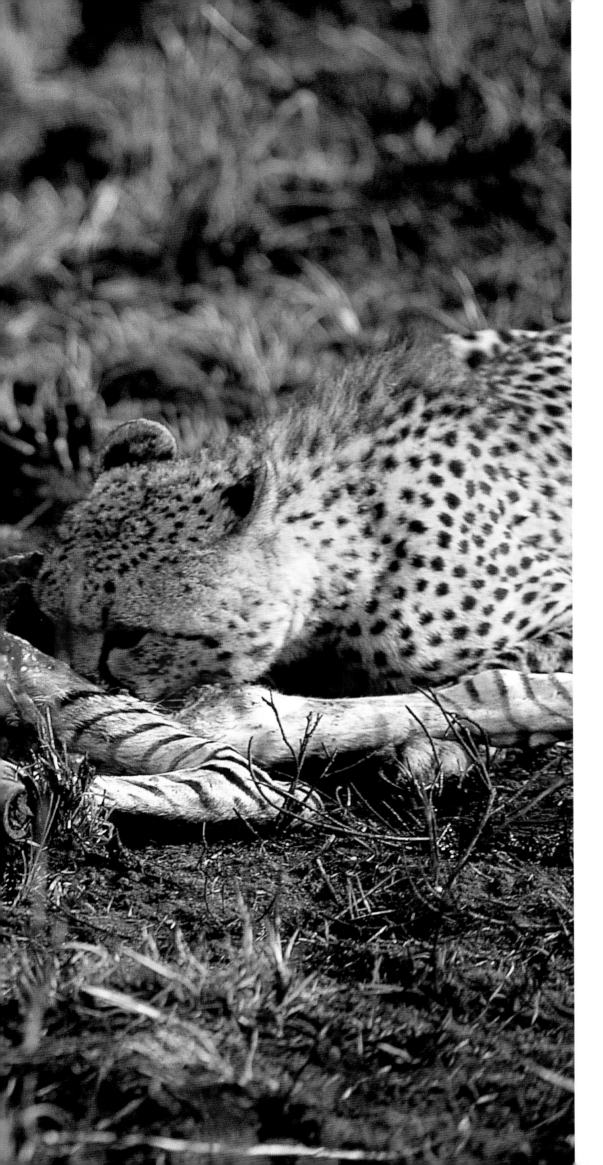

Left: *The young of large prey species such as this zebra foal are vulnerable to male coalitions but not to single cheetahs; large ungulates can defend their young from attacks by loners which is why zebras rarely feature in the diets of single males and females.*

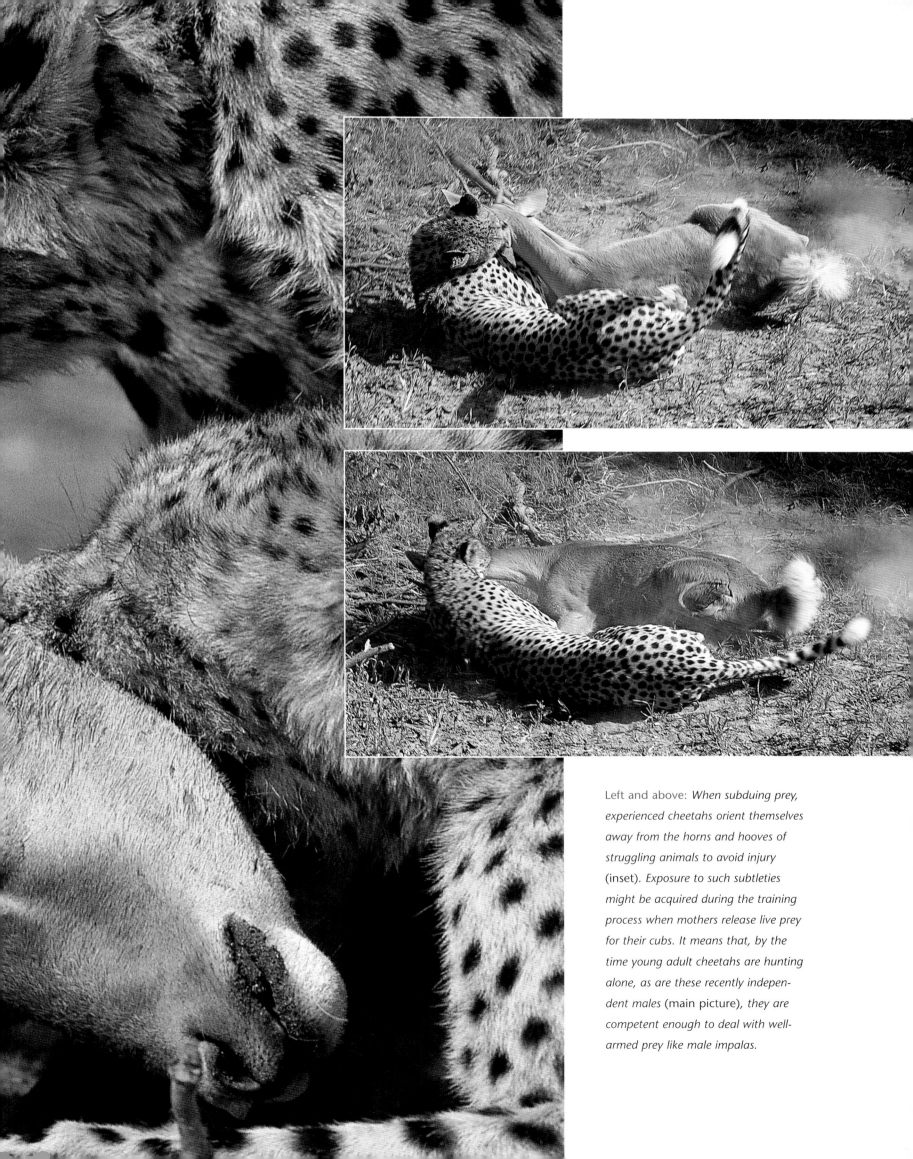

Left and above: *When subduing prey, experienced cheetahs orient themselves away from the horns and hooves of struggling animals to avoid injury* (inset). *Exposure to such subtleties might be acquired during the training process when mothers release live prey for their cubs. It means that, by the time young adult cheetahs are hunting alone, as are these recently independent males* (main picture), *they are competent enough to deal with well-armed prey like male impalas.*

THREATS AND STATUS

The cheetah is beleaguered by threats from many fronts. Adaptations for speed make it a poor combatant, relegating it to the bottom rung of the predator hierarchy wherever it occurs; cubs are often killed by other predators and adult cheetahs are easily robbed of their kills. As the planet's dominant predatory species, humans destroy cheetah habitat, their prey and the cats themselves. Where there are many people, there are few cheetahs. Even the cheetah's own genes might represent a survival crisis for the species. Together, the various threats facing the cheetah make it the most endangered large cat in Africa.

After the tiger and the snow leopard, the cheetah is the most endangered large cat – that is, in which the average female weighs at least 35 kilograms. In the 2002 Red List of the IUCN, the international body whose thousands of professional members contribute to conservation assessments, the cheetah is listed as vulnerable at the species level, a category defined as 'facing a high risk of extinction in the wild'. A number of its populations, particularly in the west and north of Africa and in Iran, are critically endangered. The cheetah is facing threats on three main fronts: those from other carnivores, those from humans, and even perhaps those from its own genes.

INBREEDING THE KING CHEETAH

Compared to its spotted counterpart, the king cheetah is unusual and therefore often held to be more valuable. Indeed, while normal cheetahs are routinely traded among zoos for as little as a thousand dollars, kings command the staggering price of between US$25 000 to US$40 000. With such a huge profit to be made, the motivation to maximise the births of kings has led to some captive facilities intentionally inbreeding their cheetahs – mating a king male to his king mother ensures that all the cubs will be kings. Driven solely by greed, the same mismanagement in some zoos has propagated white tigers, now so inbred that they suffer from a multitude of health problems.

One of the key responsibilities of zoos – embraced by the better ones – is to act as a genetic reservoir for endangered species. Well-managed breeding programmes stringently pair up unrelated animals, ensuring that the captive population retains as diverse a range of characters as possible. In such a scheme, kings hold the same value as any cheetah and are bred accordingly. Inbreeding them not only feeds the myth that they are different to and more valuable than other cheetahs, it also culls genetic heterogeneity. Ultimately, it is the cheetah that suffers.

THE GENETICS CONTROVERSY

With little doubt, the most widely publicised problem facing the cheetah is its lack of genetic variation. In 1983, felid geneticist Stephen O'Brien and his team demonstrated that cheetahs have only slightly more heterogeneity, or genetic diversity, than laboratory mice. Lab mice are purposefully bred with family members so that researchers can capitalise on their genetic similarity. Animal breeders employ the same process to 'fix' a particular characteristic; controversially, inbreeding has also been employed by some zoos to produce king cheetahs (*see* box 'Inbreeding the king cheetah' on this page).

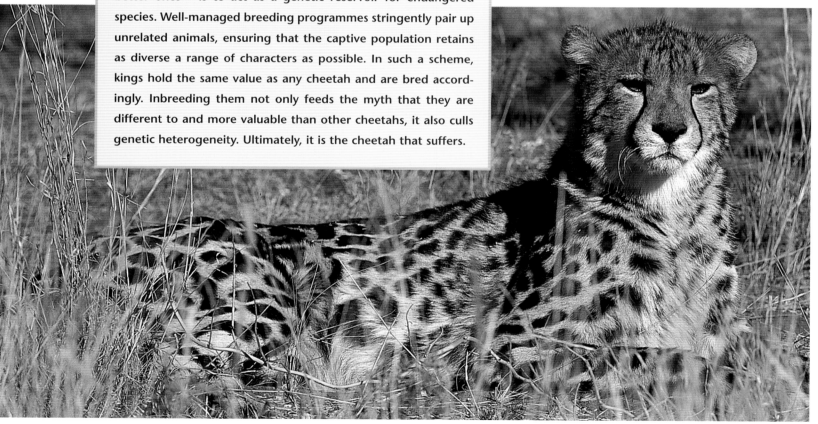

Conservationists are also addressing the isolation of parks, albeit gradually. Meta-population (literally, 'a population of populations') management attempts to treat physically isolated populations of cheetahs as they interacted before human activity carved wilderness into fragments. Mimicking natural processes such as immigration and dispersal, biologists translocate individuals between different reserves to enhance the genetic diversity in isolated populations. Even better, reintroductions of cats into areas they once occupied restore the natural connections between populations.

Meta-population projects have exciting potential, but there are substantial obstacles to success. Translocated cheetahs 'home', attempting to head back to the area they know, even if it is hundreds of kilometres away. To some extent, housing translocated cheetahs at the release site in large enclosures for a few weeks of acclimatisation overcomes the problem. Known as a 'soft release', the method seems to ease the ordeal of capture and translocation, and encourages cheetahs to settle in the new

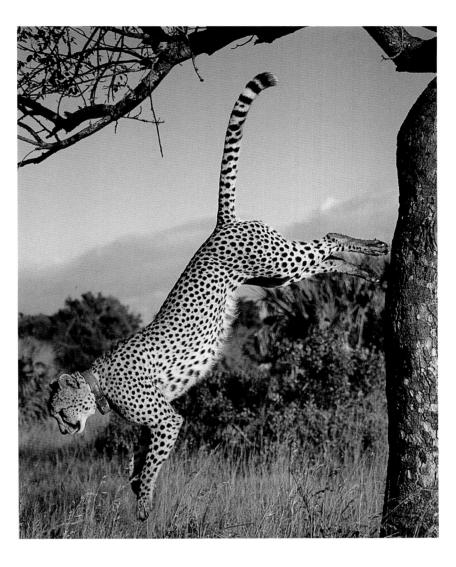

area. There have been significant soft-release successes in South Africa but, importantly, all 'reclaimed' conservation areas are fortified with electrified fences. Under pressure, cheetahs could easily cross the fence, but it acts as a further deterrent to their wandering behaviour. Notably, a trio of males soft-released in Zambia's unfenced Lower Zambezi National Park headed straight out of the park towards the direction of home. Two died in snares within six weeks of release and the third disappeared.

Setbacks notwithstanding, the projects have revealed that cheetahs can thrive when reintroduced. In KwaZulu-Natal's Phinda Game Reserve, at least 86 cubs were born to reintroduced adults between 1993 and 2002; as adults, many of the Phinda-born cheetahs have seeded other restoration projects around South Africa. Most importantly, the lessons learned could be applied to countries where the cheetah is extinct. There are currently proposals to reintroduce the cheetah into India, Saudi Arabia and Uzbekistan. The socio-economic obstacles confronting the schemes are enormous and they may never come to fruition, but if governments can address the human factor, the indications from Africa suggest that cheetahs will take care of the rest.

Not surprisingly, meta-population strategies require considerable resources and expertise. Additionally, while encouraging, they benefit relatively few

Above: *A radio-collared male cheetah leaps from a marula tree, South Africa. Radio-collars provide detailed biological information that would be impossible to collect otherwise. Contrary to widely repeated opinion, they do not bother the study animal or alter its behaviour when correctly fitted.*

Overleaf: *With around 17% of its land area under some sort of protection, Botswana is one of the few remaining African countries where cheetahs can roam over massive areas with a low danger of human persecution. Even so, the species has never been properly studied there; the number of wild cheetahs in Botswana and the species' conservation status is entirely unknown.*

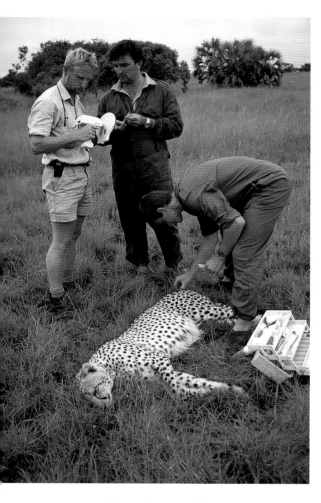

cheetahs; only a small number of cheetahs can ever inhabit protected areas and there are very real limits to the amount of land available for reclamation. Further, nations struggling to defend their established protected areas against the weight of human pressure have little hope of restoring even more land for wildlife. All of which combines to shift the conservation focus away from parks and reserves. For the cheetah's long-term survival to be a sure thing, the solution rests beyond park boundaries.

CHEETAHS OUTSIDE PROTECTED AREAS

Throughout much of its range, the cheetah is found in greater numbers outside national parks and reserves than within them. Outside the boundaries of protected areas, large predators invariably confront their greatest threat: people. Ironically, that can work in the cheetah's favour because lions and, less so, spotted hyaenas and leopards, are simply not tolerated. Lions kill livestock and occasionally people, so when one leaves the protection of a reserve, it is on borrowed time. There are now very few lion populations outside protected areas; in fact, without reserves, lions would be driven to extinction.

Lion-free regions have the potential to act as cheetah refuges, but of course only if cheetahs themselves are not persecuted. Around the parks of Kenya and Tanzania, the pastoral Masai represent a sort of coexistence model, albeit an imperfect one. The Masai have little interest in hunting herbivores so cheetah prey is usually abundant on Masai lands. Furthermore, understanding that cheetahs are far less dangerous to their herds than lions, leopards or hyaenas, the Masai rarely go out of their way to kill a cheetah. Nor do cheetahs take the poisoned baits left for stock-killers. Although it is not an entirely amicable relationship – cheetahs are killed from time to time by young herd-boys testing their skills, or perhaps because the skin can be sold – the Masai demonstrate that fairly high densities of cheetahs can live alongside people and their livestock.

Elsewhere in Africa, the association is rarely as conflict-free. The explanation lies partially in the Masai's indifference to firearms. Traditionally, predators are hunted with short stabbing spears, a method that still prevails over the use of rifles and, although not exactly predator friendly, limits the impact on carnivore numbers. Where farmers use guns – and this encompasses the great percentage of pastoral Africa – persecution is indiscriminate and far more destructive. Given the chance, most farmers shoot cheetahs. It is legal in most countries if the cheetah is deemed a threat to livestock and even where it is not, enforcement is largely non-existent and farmers shoot cheetahs anyway. Legality and weapons-of-choice aside, it begs the question, if the Masai are able to live with cheetahs, why not all farmers?

The problem of conflict remains. Cheetahs are not nearly as destructive as lions and other large predators, but they do kill livestock. The Masai suffer little because they live with their

Above, below and opposite: Zoologists in Namibia and South Africa 'processing' captured individuals. The collection of biological measurements and samples from wild cheetahs makes a critical contribution towards understanding their biology.

animals; lions kill stray cattle, and leopards sometimes raid corrals at night, but depredation (losses to predators) by cheetahs is almost non-existent. Cheetahs do not enter villages to hunt and will not confront a Masai defending his herd. The pattern breaks down on the vast commercial ranches of East and southern Africa where cheetahs and unattended stock roam free. In this scenario, sheep, goats or young calves are vulnerable to cheetahs and although losses to cheetahs are generally low, even the most tolerant farmers can endure only so much depredation before the financial imperative compels them to start shooting.

The issue for conservation on ranches becomes one of alleviating conflict, and the solutions are an ingenious combination of education and utilisation. In Namibia, conservation organizations such as the Cheetah Conservation Fund (CCF) and AfriCat are leading the way. They have demonstrated that simple changes in livestock husbandry practices can reap dramatic benefits. Electrified fencing deters cheetahs from livestock areas, and corralling stock overnight or when calves are young, as the Masai do, reduces losses.

CCF has also pioneered the use of the Anatolian shepherd dog, or Akbash, in Namibia. Originating in Turkey where they have guarded herds against wolves and bears for 6 000 years, the dogs are bonded to the herd as puppies and grow up with their charges. When confronted with a predator, the Akbash rushes to confront it rather than herd its charges, the method adopted by traditional African dog breeds, which creates panic and movement in the herd – irresistible to a hungry cheetah. In country-wide education programmes, CCF shows farmers how the combination of a guard dog with a herder – essentially the Masai model – can almost eliminate losses to cheetahs.

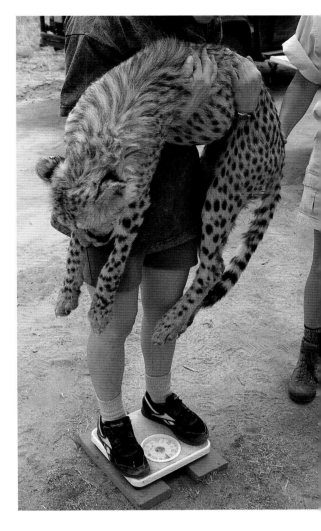

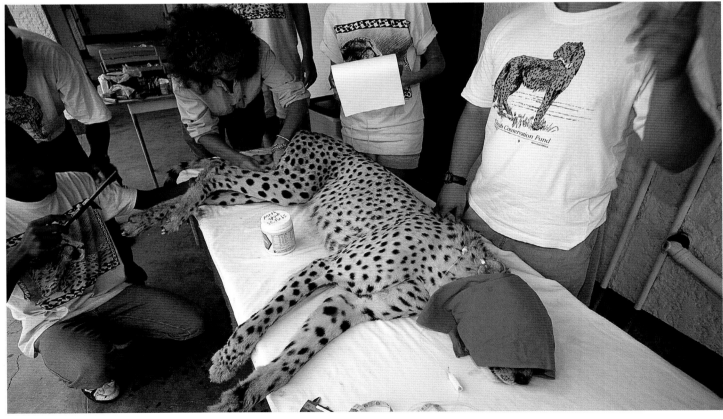

Below: *A relaxed family group of cheetahs. Views of cheetahs such as this are only possible where they are not persecuted. Outside protected areas, cheetahs are typically very shy and difficult to observe. Without dedicated conservation action, the opportunity to enjoy magnificent encounters with cheetahs such as this may be lost.*

The Namibian groups have made very impressive progress, but their methods do not work everywhere. Research conducted by CCF and AfriCat reveals that cheetahs usually eschew taking domestic stock where there is a natural alternative. On the huge Namibian ranches where wild herbivores are often abundant, the conflict problem would seem to be solved. However, in Namibia the landowner owns the wildlife ranging freely on the property. The same applies to numerous African countries where, if not having outright ownership of wildlife, the landowner is permitted by the government to utilise it. Namibian farmers harvest wild ungulates – springbok, kudu, gemsbok and others – for their skins and meat, or to sell to trophy hunters and other farmers wishing to buy the live

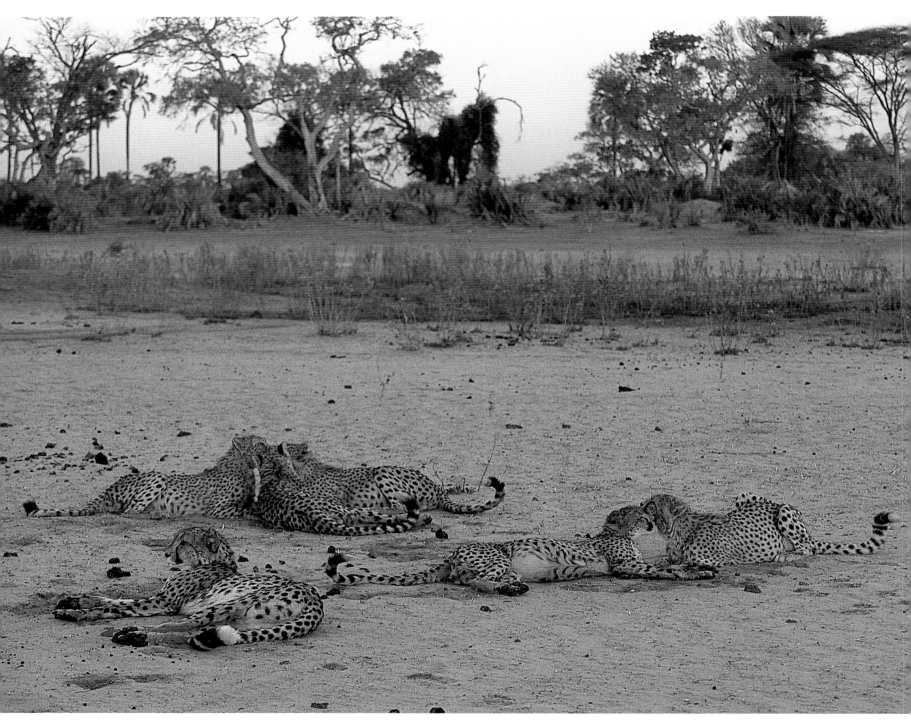

animals. To game farmers, antelopes are just as valuable (or more so) than cattle. When cheetahs compete with farmers for wild herbivores, the obstacles to conservation are far greater. Guard dogs, corrals and herders simply do not work.

One possible solution is the argument characterised as 'if it pays, it stays'; if cheetahs are valuable to farmers, they will be treated accordingly. In the most controversial application of the idea, three countries – Namibia, Zambia and Zimbabwe – permit trophy hunting of cheetahs. Whether or not hunting succeeds in conserving the cheetah is debatable (*see* box 'Can hunting conserve?' on page 132); regardless, very few cheetahs are shot by hunters each year. Namibia's quota is the highest at 150 (which includes live exports), but the difficulty of finding a cheetah during the allocated hunting period means that the quota is never filled; in 2000, 87 cheetahs were hunted, far fewer than those farmers destroyed themselves. A similar proposal from South Africa would permit limited hunting of cheetahs in the country's far north-west, where a small population lives on farmlands.

The alternative to hunting brings us full circle to the cheetah as tourist attraction for safari-goers. In a few pockets of Africa, the increasing demand from tourists hungry for photogenic wildlife is giving commercial farmers reason for pause. In marginal areas, where the yearly profit from stock farming is poised on a knife's edge, wildlife can represent a more productive and reliable source of income. A handful of farmers are now encouraging the return of wildlife to attract the tourism dollar. In South Africa, where the trend is most vigorous, growing wildlife tourism is the principal drive behind the reintroduction projects of cheetahs discussed earlier in this chapter (*see* pages 128–136). In Namibia, where reintroduction is unnecessary, a few farmers are simply growing to tolerate cheetahs because the tourists who visit their properties want to see them. Although presently limited to a few areas of southern and East Africa, private conservancies are holding increasing promise for cheetahs.

For all its vulnerability, the cheetah has demonstrated astonishing resilience. It has shown the ability to live in a far wider range of habitats than is usually assumed, it has a prodigious ability to reproduce, and where conditions are favourable it has the capacity to recolonise areas swiftly. Exemplified by its uneasy, but enduring, relationship with the Masai and farmers in Namibia, it has also displayed a rare ability to live alongside humans. Together, these characteristics give the cheetah a decent chance at evading extinction, but only if people make the active decision to allow it. The threats confronting the cheetah today are greater than ever, and they arise above all from our activities. Whether the cheetah lives or dies is entirely in our hands.

Below: *Known to biologists as lacrimal lines, the cheetah's unique tear streaks have no known function. One theory holds that they help to line up prey like a rifle's cross hairs but, more believably, they probably reduce reflected glare during day-time hunting. There are still many mysteries surrounding the cheetah, despite its being a conspicuous and well-studied species. The dedication of scientists and conservationists in unraveling the biology of this enigmatic cat is a cornerstone in ensuring the cheetah's persistence.*

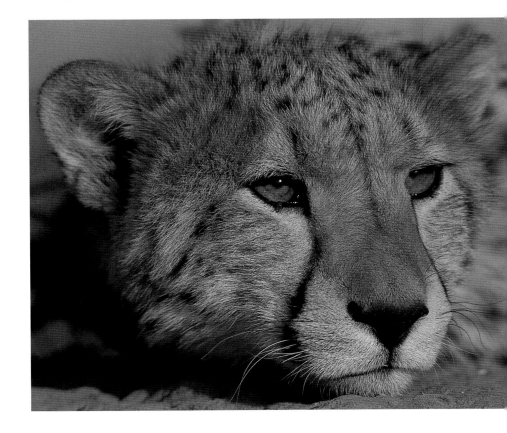